BLINKING and FLAPPING
YASUHIRO SUZUKI

まばたきとはばたき
鈴木康広

まばたきとはばたき
鈴木康広

Blinking and Flapping
YASUHIRO SUZUKI

　「人はまばたきをする瞬間、何かを見逃している」。「まばたき」という行為への着目が、見ているようで見えていない世界を意識するきっかけになりました。過去の経験の中で見えていない世界や気にとめていなかった世界が残されていたからこそ、今、発見の喜びがうまれるのです。本当に感動した個人的な発見こそ、それをかたちにして多くの人と共有できたとすれば、世界の見方を大きく更新できると信じています。そして「まばたき」（僕の発見）をはばたかせる挑戦がはじまったのです。

　本書に描かれている線画はすべて作品をつくったあとに描いたスケッチです。デザインを引き受けて下さった原研哉氏に、僕の頭の中にある作品のイメージをできる限り正確に伝えたいと思い、書き下ろしました。その的確な先導のおかげで、作品が持つ物理的な制約を超え、イマジネーションがさらなる飛躍を遂げました。
　これまで直線的な時間の中で生まれた作品が、この「本」という空間に集まり、時間から自由になったひとつの「広場」に感じられました。本書をひとつの公園と仮定すると45種類もの遊具が並んでいます。訪れた皆さんには、つぎつぎと遊具を移動し駆けまわる子供のように自由に巡っていただきたいと思っています。そしてこの広場から新しい遊びがうまれることを期待しています。

　In the instant people blink, they miss seeing something. My interest in the act of blinking triggered my awareness of the world we think we are seeing but really aren't seeing. We delight in discovery for the very reason that there is a part of the world of past experience left that we failed to see or took no notice of. I believe that if I am able to put personal discoveries that really move and excite me into physical form and share them with lots of other people, I can renew the way in which people look at the world. So I've taken up the challenge of making "blinks" (my discoveries) flap and soar out into view.

　The line drawings in the book are all sketches I drew after finishing the works. They were newly drawn for Kenya Hara, who graciously consented to do the book design, because I wanted to

give him as accurate a picture as possible of my mental images for the works. Thanks to his sound guidance, I was able to transcend the physical limitations of the works and let imagination soar to greater heights.

The works created in linear time have been gathered together in this "book" space that liberates them from time, so the book feels to me like a kind of playground. If you imagine that the book is a park, then there are 45 varieties of play equipment lined up in it. I want people who visit the park to run freely from one to the next, as children do. I hope this playground will inspire you to discover new ways of playing.

目次 Index

まばたきとはばたき　鈴木康広	Blinking and Flapping	Yasuhiro Suzuki	002

上／下	Up / Down	006
綿棒の照明	Cotton Light	014
椅子の反映	Inter-Reflection	018
ペットボトルの鉛筆削り	Pencil Sharpner with a PET Bottle	030
まばたき眼鏡	Spectacles of Blinking	034
遊具の透視法	Perspective of the Globe Jungle	038
景色の万華鏡	Kaleidoscopic Scenery	050
落書き帳	Scribbling Book	058
現在／過去	Present / Past	066
境界線を引く鉛筆	Pencil to Draw Boundaries	070
時計の針は透明な円盤を空中に描く	Clock Hands Draw Transparent Circled in the Air	078
りんごのけん玉	Apple Kendama	090
まばたきの時計	Blinking Time	098
りんごが鏡の中に落ちない理由	The Reason an Apple doesn't Fall into the Mirror	102
心拍時計	Heartbeat Clock	106
まばたきの葉	Blinking Leaves	114
時間を測るスプーン	Spoon to Measure Time	126
キャベツの器	Cabbage Bowl	134
木の葉の座布団	Zabuton of Leaves	142
ファスナーの船	Ship of the Zipper	154
水の素質	Propety of Water	170
うしろ姿の模型	Figure of the Back View	178
けん玉の蝋燭	Candle of a Kendama	186
スプーンの蝋燭	Candle of the Spoon	190
？のあめ	? Candy	194
炎のマッチ	Matches of Flame	198

凡例
作品のサイズについては、平面作品を縦×横、立体作品を縦×横×奥行(直径)で記した。
小数点以下1桁まで明記しているが、「.0」の場合は省略した。

目薬の銃	Eye Dropper	202
気配のクッキー	Cookies Sensed But Not Seen	206
自画像のパズル	Self-Portrait Puzzle	214
水平線の消息――色鉛筆	Note from Sea Horizon — Colored Pencils	218
水平線の消息――ひも	Note from Sea Horizon — Rope	222
りんごの天体観測	Constellation of Apples	230
スープの満ち欠け	Phases of Soup	238
蛇口の起源	The Origin of the Word "Jaguchi"	242
空気の人	Aerial Being	246
バケツの切り株	Bucket Stump	254
銀閣寺のチョコレート	Chocolate Ginkaku-ji	258
繊維の人	Fiber Being	262
自針と分針	People Hand and Minute Hand	266
木のこま	Spinning Top Trees	270
空気の鞄	Aerial Luggage Bag	274
募金箱「泉」	Donation Box Called Well	278
まばたき採集箱	Specimen Box of Blinking	282
まばたき証明写真	Blinking ID Photos	286
日本列島の方位磁針	Compass of Japanese Islands	290
作品相関図	Correlation Diagram	294
それは数式のように生長している　原 研哉	Art that Grows with the Beauty of a Mathematical Formula　Kenya Hara	296
生命の光源　茂木健一郎	The Light Source of Life　Kenichiro Mogi	300
シンプルな疑問　川内倫子	A Simple Question　Rinko Kawauchi	304
鈴木康広と《募金箱「泉」》をめぐって…　青野和子	Thoughts on Yasuhiro Suzuki and "Donation Box Called Well"　Kazuko Aono	306
作品リスト	Lists of Works	312
略歴	Biography	318

「上」という文字が紙の裏側に透けると「下」に見えることを発見しました。
それ以来、「上」と「下」の表裏の関係がずっと気になっていました。

I discovered that the Japanese kanji 上 (up) seen through the back of transparent paper looks like the kanji 下 (down). Since then I've wondered about the front-back relation between up and down.

上 ／ 下
Up / Down

1997 判子／Stamp: 6 × 1.7 × 1.7cm 紙／Paper: 1.5 × 12.3 × 16.5cm	素材. 木材、ゴム印、紙 Material: Wood, Stamp and Paper

描かれた空気のかたち

← 上と下の境界

「上」を切り抜いた紙を何層も重ねてめくってみたところ、上と下が連続した空気の
彫刻がうまれました。上と下の境界は見る人の目線の高さにあることに気づきました。
同じように紫外線で光るインクを使って「上」の像をめくってみたところ、
今度は残像として光の立体が現れました。

When I cut the shape 上 from many sheets of paper and stacked up the sheets,
it made a series of air sculptures of 上 and 下. I noticed that the boundary
of 上 and 下 was the height of the viewer's eye level. Then I did the same thing
using ink that shone under ultraviolet light to print 上. When I flipped
the sheets of paper, a three-dimensional light afterimage appeared.

「上」「下」は紙の表裏で一致するだけでなく、パラパラマンガの仕組みで「上」を上方向に動かしてみたところ、「下」は下に動き出しました。はじめにこの文字を考えた人がいるはずですが、その瞬間に立ち会えたような気持ちになりました。

上 and 下 don't just match on the back and front of paper; put in flip book form, when 上 is drawn to move in an upward direction, 下 starts moving down. Someone was the first person to think up these two kanji; I felt like I was there to witness that moment.

綿 棒 の 照 明
Cotton Light

2000
9.1 × 10.9 × 8.1cm

素材: 綿棒、電球
Material: Cotton Swab and Electric Light Bulb

ケースに収まっている綿棒の質感と構造が以前から
気になっていました。中に電球を入れてみたところ、外からは
光源が見えないやわらかい反射光の照明になりました。

The texture and structure of cotton swabs packed in a case have
interested me for a long time. I tried putting a light bulb inside
cotton swabs and the result was a light fixture that emits soft
reflected light whose light source can't be seen from the outside.

綿棒が電球をつつみこむ

綿棒が同心円状に隙間を満たしているので直接光源は見えず、
自然に間接光になる合理的な構造です。ところが、電球が発する熱の問題で
短い時間しか点灯させることができませんでした。その後、LEDを使って
綿棒も詰め替えできるものもつくってみました。

This is a practical structure that naturally emits indirect light because the cotton swabs fill up the gaps in the concentric circles they make around the light bulb hiding the direct light source from sight. Due to the problem of the heat given off by the light bulb, the light could only be turned on for a short time, so I used an LED bulb to make another light fixture that was refillable with cotton swabs.

Photo: Kawauchi Rinko

椅子の反映
Inter-Reflection

2001
椅子／Chair:
3.5 × 2 × 2.5 cm
装置／Equipment:
10 × 80 × 80 cm

素材: 木材、アクリル樹脂、モーター、ビデオカメラ、赤外線センサー、プロジェクター
Material: Wood, Acrylic Plastic, Motor, Video Camera, Infrared Sensor and Projector

巨大な椅子が部屋の右から左へ音も立てずに流れていきます。じつは床に置かれた円盤上のミニチュアの椅子がリアルタイムで壁面に投影されています。見ている人がそのしくみに少しずつ気づきはじめる空間です。

Giant chairs move from right to left of a room without making a sound. Actually it's the image of miniature chairs placed on a disk on the floor that is projected on the wall in real time. The space is set up so that the viewer slowly becomes aware of this mechanism.

スポットライトに仕込んだ小型カメラで撮影しています。ベアリングの
かすかな摩擦を経由して回すことでゆるやかな回転になりました。
動きはじめと停止する寸前を、ミニチュアと現実の空間をなめらかに
つなぐために試行錯誤しました。

The chairs are filmed with a small camera attached to a spotlight.
I got the spotlight to revolve slowly by capitalizing on the slight friction of
the bearing. I went through trial and error to obtain seamless movement
between the chairs in the projected image and the camera when it starts
to move and right before coming to a stop in the miniature space.

Photo: Kawauchi Rinko

椅子の影が「音符」に見えたのがきっかけでした。8分音符、16分音符、32分音符の椅子の影が、円盤上の五線譜に無音のリズムを奏でます。人が近づくとゆっくり回転をはじめ、人がいなくなるとゆるやかに静止します。

The idea for this work came from the resemblance of the chair shadows to the shape of a musical note. The eighth, sixteenth, and thirty-second note chair shadows play a soundless rhythm on the staff notation on the disk. It slowly begins to revolve when someone comes near it and slowly comes to a stop when people walk away.

Photo: Kawauchi Rinko

五線譜に記される音の空間と、実空間の奥行きの中にうまれる
「音」の空間があり、この二つを重ねてみたいと思いました。椅子を回転させて
空間に溶かし込む感覚、あるいは椅子の空間が人の意識の中で
音楽になる瞬間をイメージしました。

There is a space of sound notated on the staff and a "sound" space
generated at the back of the actual space; I wanted to see what would happen
if I combined them. I imagined the sensation of the chairs revolving
and melting into the space, or the instant when the space containing
the chairs becomes music in a person's consciousness.

椅子があると、そこに座る人間を想起させます。座れないミニチュアの椅子は、
人の体を小さな空間に引き寄せる力を持っているような気がします。
小さな世界と大きな世界を同時に体験することは、無意識に自分のからだの
大きさを確かめることにつながっています。

 A chair brings to mind someone sitting on it. I think the miniature chairs
with no one sitting on them have the power to pull people into the small space.
The simultaneous experience of a small world and a large world causes people
to unconsciously start wanting to make sure of the size of their body.

ペットボトルを筆洗いとして使っていたとき、容器の中に鉛筆を差し込むイメージが頭に浮かびました。透明なペットボトルも削りかすも、捨てられる寸前とは思えない程きれいなものだと思っていました。溜まった削りかすは自分の使った色の地層となって積み重なっていきます。

I was washing brushes in a PET bottle when I suddenly got the image of putting a pencil in a container and sharpening it. The transparent PET bottle filled with pencil shavings looked nice, so it was hard to imagine it being thrown away in the next instant. The pencil shavings of different colored pencils accumulate in the bottle to form colorful geological strata.

ペットボトルの鉛筆削り
Pencil Sharpner with a PET Bottle

2001 3×3×3.1cm	素材: フフスナック、刃、ペットボトル Material: Plastic, Edge and PET Bottle

別の言い方をすれば、この鉛筆削りは通過するものを規定する境界線です。
あるいは鉛筆をペットボトルに入れさせてしまうフタとも言えます。
鉛筆が削られていく様子が見えることもポイントでした。削りかすは鉛筆を
展開した一つのかたちだと気づきました。

Put another way, this pencil sharpener acts as a boundary line that defines things
that get put through it. Or it could be called a lid that lets pencils be put in
the PET bottle. Another point is that it lets you see the pencil as it is being sharpened.
I regard pencil shavings as a different form developed from a pencil.

Pencil Sharpner with a PET Bottle

まばたき眼鏡

Spectacles of Blinking

2001
5 × 14 × 17cm

素材: プラスチック、モーター、ソーラーパネル
Material: Plastic, Motor and Solar Panels

まばたきをテーマにした最初の作品です。まばたきが自分の行為でありながら
同時に自分ではないような、意識と無意識の間にあるあいまいな部分に
興味を持ちました。この眼鏡は自分の意志とは無関係にまばたきをおこす装置です。
見ていたつもりでも見えていないものがあることを意識するようになりました。

This is the first work I created on the theme "blinking." The ambiguous aspect
of blinking interested me — it's a conscious act and yet you don't really do it
consciously, so it's somewhere between deliberate and not deliberate.
These spectacles are a device that blinks entirely unrelated to your own will.
I became aware that there were things I was not seeing even though
I was intentional looking at them.

Spectacles of Blinking

電華　まぶた

モーター

ソーラーパネル

アクリル

視界の薄片

太陽電池の入った「目」を両手に持ち、それを太陽に向けることでモーターが
作動してまぶたがパタパタと開閉します。日なたではまばたきの勢いが増し、
日陰に入るとまぶたは閉じてしまいます。装着すると、一羽の鳥が目の前で
さわがしく羽ばたいているような感じになります。

When the "eyes," equipped with a solar battery, are held up toward the sun
with both hands the motor starts up and the eyelids flap open and close.
In the sunlight the blinks speed up and in the shadow the eyes close.
When you put on the spectacles, a bird seems to be right in front of your eyes
busily flapping its wings.

Photo: Kawauchi Rinko

遊 具 の 透 視 法

Perspective of the Globe Jungle

2001	素材: グローブジャングル、プロジェクター、
320 × 230 × 230 cm	スピーカー、DVDプレーヤー
	Material: Globe Jungle, Projector, Speaker and DVD Player

昼間グローブジャングルで遊んでいる子供たちをビデオカメラで撮影し、その映像を、夜、同じ遊具へ投影します。昼の子供たちが夜の遊具に反射して、残像となって公園によみがえる、不思議な空間が立ち現れました。

With a video camera, I filmed children playing in the daytime on a globe jungle and projected the images onto the same globe jungle at night. A mysterious space rose up when the children playing in the daytime reflected on the globe jungle at night came alive as afterimages in the park.

回転による残像現象を利用して、構造体そのものを球面のスクリーンにしました。
子供が遊んでいる様子と遊具の内側から撮影した公園の景色を
二方向から投射します。遊具の内側から撮影した公園の景色を外側から
投影すると、まるで遊具を境界に世界を裏返したような光景が現れます。

I made the structure itself a spherical screen, using the phenomenon of
afterimages produced by the spinning. I projected the park scenery filmed
from inside the globe jungle and the children playing from two directions.
Looking at the park scenery filmed from inside the globe jungle and
projected from outside was tantamount to seeing the world turned inside out
with the globe jungle as the boundary.

2次元　　　　　3次元

遊具の内側から公園を撮影（子供の視点）

人の手で回す

プロジェクター

油をさす　　　遊具の外側から撮影した映像

この遊具で遊ぶ子供たちの影が大陸に見えるという発見は、
作品を制作してからうまれました。太陽という究極のプロジェクターによって、
地球の表面に投影されていました。遊具は子供たちが加わってはじめて
「地球」の影を完成させていたのです。

After I finished the work I made the discovery that the shadows of the children playing on
the globe jungle looked like continents on the globe. They had been projected on
the earth's surface by the sun, which is the ultimate projector. It was only when the children
got on the globe jungle that the "earth" shadow was completed.

Photo: Kawauchi Rinko

Perspective of the Globe Jungle

昼に遊ぶ子供たちの光景を夜の公園によみがえらせることで、地球の自転を意識しました。昼と夜の繰り返しの中に圧縮されている人々の記憶を解凍するかのように、時間を超えたさまざまな思いが行き交いました。

I became conscious of the earth's rotation when the scenes of
children playing in the daytime were revived in the park at night.
Thoughts and feelings came and went, transcending time;
it was almost like defrosting people's memories that have been
compressed in the repetition of day and night.

地球と太陽、遊具とプロジェクターの関係が重なって見えたことで、
今ここに投影されている影の見え方が変わりました。地球の上に立っている
あらゆる物の最もリアルな存在証明は、太陽が投射する自分と
物の影ではないかと思います。

Because the relation between the earth and the sun seemed to coincide with
the relation between the globe jungle and the projector, it changed the way
in which I perceived the shadows that were projected. I think the most real proof
of the existence of all the objects and living beings that stand on the earth is
their shadows projected by the sun.

夜

昼

大陽

球体の中をのぞくと、グローブジャングルの内側から眺めた公園の
景色が見えます。液晶画面をミラーで囲むことで、上下左右あらゆる方向に
反転した景色が同時に目の中に飛び込んできます。

Look into the spherical object and you can see park scenery as if you were
looking out at it from inside a globe jungle. A liquid crystal display surrounded
with mirrors reflects the scenery in all directions up, down, left, and right,
and all of these views leap to the eye simultaneously.

景 色 の 万 華 鏡
Kaleidoscopic Scenery

2001 23 × 23 × 23cm	素材: プラスチック、レンズ、鏡、 ビデオカメラ、スピーカー Material: Plastic, Lens, Mirror, Video Camera and Speaker

レンズ

ミラーボックス

スピーカー

液晶画面（ビデオカメラ）

アンプ

四面ミラーボックス
風景を上下左右あらゆる方向に反転する

のぞくだけで遊具に入った時のめまいを呼び起こします。のぞいている感覚が、
だんだん球体が頭と一体化して、まるで頭だけが遊具の中にあるような
気分になってきます。この装置そのものが目玉の構造に似ていて、球体に自分の
網膜をのぞき込ませているように思えてきました。

Just looking at it evokes the dizziness felt when riding on a globe jungle.
The sensation of looking is gradually replaced by integration of the sphere and
the mind. You get the feeling that your mind is inside the playground equipment.
The device itself is similar to the structure of an eyeball, so it seemed like I had
the sphere peering into my own eyes.

Kaleidoscopic Scenery

《遊具の透視法》と同時期に制作しました。内側から見た景色を
外からのぞき込む感覚と、視覚と聴覚だけで、遊具の中に入った時の
感覚を呼び起こします。

I created "Kaleidoscopic Scenery" during the same period as "Perspective of the Globe Jungle." The feeling of riding on the Globe Jungle is produced from the sensation, involving only the visual and auditory senses, of looking from outside at the scenery seen from inside the Globe Jungle.

Kaleidoscopic Scenery 056 | 057

落 書 き 帳

Scribbling Book

2002
1 × 25.5 × 35.5 cm

素材: 画用紙
Material: Drawing Paper

ある日、街を歩いていたら、道端に落ちて踏まれていた紙がアスファルトの
地面にぴったり張りつき、模様を写しとっていました。それを見かけた瞬間、
街の断片を画用紙にエンボスすることを思いつきました。

One day I was out walking in the city and saw a piece of paper lying on the side of the street; it had been trampled on so that the pattern of the asphalt was imprinted on it. Instantly it gave me the idea of embossing segments of the city on drawing paper.

厚紙を切り貼りした型に画用紙をあて、スーパーボールで
手押ししています。身のまわりの様々な模様をわずか0.5ミリの
凹凸によっていかに表現するか、試行錯誤しました。

Drawing paper is placed on cut-out cardboard shapes and pressed by hand with a super ball. It was a process of trial and error to see how well a variety of patterns around me could be drawn with 0.5 millimeter bumps and dents.

見慣れた物質の表面を紙の凹凸によって抽出することで、不思議な抽象性が
うまれました。本物から抽出された抜け殻のようなパターンから、
記憶の中の街が頭の中に立ち上がるような感覚です。紙が持つ存在感の
透明性を再認識しました。

A strange abstractness is obtained by drawing a sample of some familiar object on paper with bumps and dents. It was the sensation of making a mental transfer from patterns resembling empty shells extracted from real objects to objects in the city of my memory that stand up in my head. I rediscovered the transparent presence of paper.

現　在　／　過　去	
Present / Past	
2002 0.6 × 2.5 × 6 cm	素材: 木材、ゴム印 Material: Wood and Stamp

現在という瞬間は判子を押すともう過去になってしまいます。
時間について、とくに瞬間について考えると、「現在」を認識することは
不可能なことに思えてきました。過去という文字が現れた瞬間の
はっとした感覚そのものが、時間の最小単位なのかもしれません。

As soon as the stamp is stamped, the "present" instant becomes the "past."
In thinking about time, especially an instant of time, I've come to feel
that it's impossible to perceive the "present." It might be that the sense of
surprise itself we feel at the instant the word "past" appears is
the smallest unit of time.

過去

Photo: Kawauchi Rinko

人間の認識そのものにもわずかな時間がかかっていることを考えると、
自分自身の中に決して追いつけない「ずれ」があります。さっきの自分／
今さっきの自分／今の自分。自分の記憶をさらに微分していったとき、
自分はどこにいるのでしょうか？まばたきは自分の「今」を切り取る
最もシンプルな現象のような気がします。

瞬間における自分自身の消息-
なす

言い(何

言い(何

Considering the brief amount of time involved in the process of
human cognition, there is a time lag in us that is impossible to catch up with.
Past me/just past me/now me. When I divided my memory further into briefer
units of time, I couldn't help wondering where exactly I was. I believe
the blink is the simplest phenomenon for cutting out your "now."

Photo: Kawauchi Rinko

境 界 線 を 引 く 鉛 筆

Pencil to Draw Boundaries

2002	素材: 色鉛筆、接着剤
0.8 × 17 × 0.8 cm	Material: Colored Pencils and Glue

二色が一つになった色鉛筆で線を引くと、目に見えない線が引けることに
気づきました。青と水色の《水平線を描く鉛筆》、青と黄土色の《地平線を描く鉛筆》、
白と黒の《境界線を引く鉛筆》は、実体のない「境界」がテーマです。数学で習った
観念として存在する幅のない線を思い出しました。

 I found that by drawing a line using one colored pencil made
from two colored pencils, I can draw a line that can't be seen with the eye.
The theme of "Pencil to Draw the Sea Horizon" in blue and light blue,
"Pencil to Draw the Earth Horizon" in blue and ocher, and "Pencil to Draw
the Horizon" in white and black is "incorporeal boundaries."
This work reminded me of what I learned in math class about a line
without width that exists as a concept.

二色の色鉛筆をそれぞれかんなで半分に削り落とし、接着しています。
削り去られていったもう一組の鉛筆の存在が気になりました。線を引くとき、反対側に
ひそんでいるようです。木材どうしの隙間や表面をコントロールするかんなそのものが、
無数の境界線を生み出す道具であることに気がつきました。

I use a plane to shave off half of each pencil lengthwise and then glue
the pencils together. But those other two shaved-off pencil halves are in the back
of my mind; when I draw a line, they seem to be hiding on the other side.
I discovered that the plane, because it controls wood surfaces and the gaps
between pieces of wood, is a tool that creates countless boundaries.

Pencil to Draw Boundaries 072 | 073

Pencil to Draw Boundaries

最初に考えたのは、天と地を分ける地平線のアイデア。地平線は幅のない線なので、細い色鉛筆の中の地面と空の風景は、縮小とも実物大の一部としても見ることができます。画用紙に描いた粗いかすれが、風景をリアルに感じさせてくれます。《水平線を描く鉛筆》のかすれは水面のきらめきや空に浮かぶ雲に見えます。

Initially, I got the idea for the horizon line separating the earth and the heavens. The earth horizon is a line without width, so you can view the ground and sky scene made by the thin colored pencil line as either being scaled down or part of a full-scale scene. The coarse texture on drawing paper makes the scene seem real. The coarseness of the line in "Pencil to Draw the Sea Horizon" has the appearance of a sparkling water surface and clouds floating in the sky.

時計の針は透明な円盤を空中に描く
Clock Hands Draw Transparent Circled in the Air

2003
50 × 100 × 100 cm

素材: ステンレス・スチール、モーター、コントロールシーケンサー、プロジェクター、DVDプレーヤー
Material: Stainless Steel, Motor, Control Sequencer, Projector and DVD Player

ゆっくりと時を刻んでいる秒針が、ある瞬間、高速回転をはじめます。空中に半透明のスクリーンを浮かび上げ、そこに映像の針や数字を投影しました。物体の針と映像の針が同じ残像となって人の網膜に飛び込んできます。

The second hand of a clock slowly marks the passing of time. In an instant it begins to speed up. I hung a semi-transparent screen in the air and projected images of the second hand and numbers onto it. The second hand of the object and the images of the second hand become the same afterimage and leap into the eye of the viewer.

針（スクリーン）

映像をはねかえすための鏡

モーター

上の針とバランスをとるためのもう一本の針

プロジェクターから投影された映像の針

高速回転している針

鏡

鏡に映り込んだ映像の針

針が数字をかきあつめながら回転し円盤上をかきまぜる

とつぜん針が折れて分解する それぞれの針に中心がうまれて回転をくり返す

人が動くものを認識するには、ある一定の時間が必要です。それより短い時間だと、ものは無いことになってしまいます。この時計は時間を計るためのものではなく、「人の網膜に像が認識される時間」を見せているのです。

It takes a certain amount of time for people to detect movement. If the time is shorter than the time that is necessary for detection, then it's the same as if there is nothing there. This isn't a clock for measuring time; it shows people how much time it takes for them to visually detect an image.

Clock Hands Draw Transparent Circled in the Air

Clock Hands Draw Transparent Circled in the Air

針の裏を鏡にしたところ、合わせ鏡になって針の中に針が次々と映り込みました。
奥にいけばいくほど針の幅は狭くなり、針に幅がなくなる瞬間がおとずれます。

I put a mirror behind the second hand so that I had coupled mirrors
which reflected second hands within second hands. The farther back
the reflection the narrower the second hands become, so the instant comes
when the second hand ceases to have width.

空間を刻む幅のない針

究極の中心は
回転していない

← 針の消失点

鏡

鏡

← 針の消失点

街の建物や木々に囲まれた360°全天周の風景を、時計の文字盤に
見立てました。すると円盤に映る木々の隙間と目盛りの関係が
似ていることに気づきました。この場合、円盤の中心には針の軸ではなく、
景色をとらえる視野の中心があります。

ビデオカメラ

アクリル（透明な筒）

ミラー半球

ミラー半球に映り込んだ360°の景色を撮影する

自分は映らない
ように
木にかくれる。

カメラ

I used the dial plate to illustrate a 360-degree panorama of sky surrounded by a cityscape of buildings and trees. I noticed the relation of the spaces between the trees reflected on the disk and the numbers on a clock dial plate. In this case, the center of the disk is not the second hand but the center of the visual field of the eye that views the scenery.

木

幹の無数のかさなりが 文字盤の目盛りと同じようにすきまを満している

太陽のように強力な
プロジェクター

けん玉は地球の引力を利用した遊びです。それに気づいて赤い玉を
りんごの形にしました。ニュートンもりんごから万有引力の法則を着想したと
言われています。月とりんごという一見かけはなれたものどうしをつなぐ
視点は、けん玉の「見立て」の世界とつながっています。

Playing with a kendama makes use of earth's gravity. That's why
I made the red ball in the shape of an apple. Newton is said to have arrived
at Newton's law of gravitation by starting with an apple. A perspective
that associates the moon and the apple, which are superficially quite
unlike each other, is linked to "comparing" the kendama to the world.

りんごのけん玉

Apple Kendama

2003	素材: 木材、ひも
19 × 7 × 7cm	Material: Wood and String

※ Kendama is a toy that consists of a wooden ball attached by a long string
to an object similar to a wooden hammer. The hammer head is indented on
both ends to form two shallow cups for catching the ball.

いつ落ちてくるかわからないりんごと、そのりんごが落ちるときに
棒でサクッと射止めたい人間（僕）。自然と自分とのあいだにある見えない関係を
相手にする、きわどい遊びがこのけん玉の起源です。

An apple that may fall at any time, and a person (me) who wants to capture
that apple with a stick when it falls. Kendama has its roots in the risky play of
challenging the invisible relation between nature and yourself.

Apple Kendama

Photo: Kawauchi Rinko

Apple Kendama

まばたきの時計

Blinking Time

2003
9×19×9cm

素材: 木材、写真、モーター、アクリル樹脂
Material: Wood, Photograph, Motor and Acrylic Plastic

デジタル時計がパタッとめくれた瞬間を偶然目撃するとなぜか少し嬉しくなります。
この時計はその瞬間のためにつくりました。数字や目盛りによって正確に
時を示す時計ではなくて、自分が今ここにいることを直感的に気づかせてくれる、
時間の「鏡」のような装置です。

I don't know why, but whenever I happen to hear the click at the moment a
digital clock changes numbers I get kind of a happy feeling.
This clock is made for that moment. It's not a clock that accurately displays
time with numbers or graduations; it works like a time "mirror" to make
you directly aware that at this moment you are here in this place.

Blinking Time

時計がめくれる瞬間を狙って意識して見つめていても、思わずよそ見を
してしまったり、自分の方がまばたきをしてしまい見逃すこともあります。
めくれてもめくれても同じ顔なので、見る方がまばたきをすると
めくれたかどうかもわかりません。見ているようで、見えていない
タイミングを計るための時計です。

When people consciously gaze at the clock waiting for the instant it changes, they sometimes look away without thinking or blink and miss the moment. It's the same face no matter how many times it changes, so if you blink, you don't know whether it has changed or not. The clock measures the timing of when you seem to be looking but you're really not.

りんごが鏡の中に落ちない理由

The Reason an Apple doesn't Fall into the Mirror

| 2003 | 素材: りんご、鏡 |
| 10 × 20 × 20 cm | Material: Apple and Mirror |

鏡の上にりんごが着地すると、映像のりんごも反対側から鏡の中で着地しました。二つのりんごが、それぞれ互いに落ちてしまわないように支え合っているように見えて、理科で習った作用／反作用の法則を思い出しました。それ以来、物が静止してそこにあるとき、反対側にひそんでいる反作用の存在が気になって仕方がありません。

When an apple lands on the mirror the image of an apple lands in the mirror on the opposite side. The two apples look like they are supporting each other to keep from falling. It reminded me of the law of action and reaction I learned in science class. Since then, when some object near me is stationary, I can't help wondering about the existence of the reaction hidden on the opposite side.

物体のりんご

鏡

映像のりんご

釣り合う二つのりんごについて考える人と、釣り合う二人について
考えている(かもしれない)りんご。物体も触らなければ映像です。
それに気づいて、物体のりんごと映像のりんごを区別しなくなりました。
どちらかが偽物ということではないのです。

A person thinking of two counterbalancing apples and an apple (maybe) thinking of two counterbalancing people. If you can't touch the object, it's an image. When I noticed that, I stopped making a distinction between the real apple and the image of an apple. It's not a matter of one of the two being fake.

The Reason an Apple doesn't Fall into the Mirror

人の指先から心拍をセンシングし、光に置き換えて見せる作品です。
心臓のリズムが暗闇の中に光の輪となって浮かび上がり、砂時計のような
形を立体的に描き出します。

The heartbeat clock senses the heartbeat from a person's fingertip and
displays it as light. The rhythm of the heartbeat becomes a ring of light that
emerges in the darkness, forming a three-dimensional hourglass shape.

心 拍 時 計

Heartbeat Clock

2003	素材: スチール、モーター、コンピューター、
150×75×75cm	心拍センサー、スピーカー、プロジェクター
	Material: Steel, Motor, Computer,
	Heart Rate Monitor, Speaker and Projector

回転

プロジェクター

心拍センサー

モーター

赤外線フォトカプラ（心拍センサー）
毛細血管の血流をとらえる

二人で指をかざすと、Aさんの心拍が上から、Bさんの心拍が下から進み、
それぞれのリズムが重なり合います。自分の両手を使うこともでき、二人の「私」の
心拍が交差する瞬間を見ることができます。

When two people put their fingers on the clock, A's heartbeat moves up,
B's heartbeat moves down, and their separate rhythms overlap. You can use both
your hands to see the instant the heartbeats of the two "yous" intersect.

心拍のラインが重なり合うことで かたちが浮かびあがる

このスクリーンは、「一つのものが二つに分かれる寸前のかたち」です。
胎児が母親の胎内にいる時には、一つの体の中に二つの心臓が
同居しています。記憶には残っていないその体験を想像しながら、
自分の心臓と他者の心臓の対話がはじまります。

The screen is the shape of something right before it splits into two.
While the baby is in its mother's womb there are two hearts in one body.
As you imagine this experience which doesn't remain in memory,
a dialog begins between your heartbeat and the other person's heartbeat.

モーター

指先の毛細血管から微細な血流の変化をキャッチするテクノロジーにも
感心しましたが、指先まで心臓の鼓動が正確に伝わっていることに
新鮮な驚きがありました。まるで指先に小さな心臓があるようです。

Technology that can pick up very slight change in blood flow in the capillary
vessels of the fingers was impressive, but it was a refreshing surprise to
learn that the beat of the heart reaches accurately all the way to the fingertips.
It's like there are little hearts in the fingertips.

Photo: Kawauchi Rinko

表には開いた眼を、裏には閉じた眼をプリントした
紙を葉の形にカットすると、空中でくるくると回転して
「まばたき」をしているように見えます。

Leaves cut from paper printed with eyes open
on the front and eyes closed on the back look like
they are blinking as they spin around in the air.

まばたきの葉
Blinking Leaves

2003
葉／Leave:
10.5 × 5.5 × 0.02 cm
装置／Equipment:
600 × 80 × 80 cm

素材: 紙、繊維強化プラスチック、
送風機、木材、ベンチ
Material: Paper, Fiber Reinforced Plastics,
Air Blower and Bench

挿入口　　　挿入口

葉をかき混ぜながら吹き上げることで
詰まりを防ぐ

シロッコファン（送風機）

空気取り込み口

100V

Photo: Ichikawa Katsuhiro

円筒を幹に見立てることで、吹き上げられた葉が「木」を描き出しているように
見えてきました。透明な枝を一瞬にして空間にはりめぐらし、落葉樹の
一年のサイクルをわずか数秒で表現しているように見えてきました。たくさんの葉に
頭の先から包み込まれる感覚は、自分も1本の木になったような気分になります。

If the cylinder is likened to a tree trunk, the leaves blown upward appear
to form a tree. For an instant, invisible branches grow out in the air;
it looks like the annual cycle of a deciduous tree depicted in just a few seconds.
I felt like a tree myself as I was enveloped with so many leaves
floating down around my head.

葉が次々と差し込まれ人の手から飛び立っていく様子は、「木」に身が
乗り移っているようにも感じられました。子供たちは無心に葉を拾い集め、
舞い落ちる葉を必死に追いかけます。はじまりもおわりもない永遠に
続きそうな遊びの空間がうまれました。

As more and more leaves were put in the cylinder, the sight of the myriad
of leaves floating down, touching and flying off people's hands gave me
the feeling that they had turned into trees. The children were engrossed in
gathering up the leaves, chasing furiously after them. The installation produced
a play space without beginning or end that seemed to go on forever.

Photo: Kawauchi Rinko

飛びだすころには再び葉となって
まばたきしながら散る

葉は入れた瞬間鳥となって
羽ばたく

Blinking Leaves

空高く打ち上げられた葉は上空に巨大な「木」を描き出し、街は一瞬にして
「まばたき」に包み込まれます。そのときに使う葉は食用の紙でつくろうと考えています。
環境のことを考えて土に還すためでもありますが、もしかすると空腹の鳥が
空中でキャッチして、ついに「まばたき」と「はばたき」が出会う瞬間が
見られるかもしれないと思っているのです。

All of the leaves blown high up into the sky would create a giant "tree" in the air; for a moment, the city would be enveloped in "blinks." For that installation I would make the leaves out of edible paper because it would be good for the environment if the leaves could be returned to the soil. But the main reason is that I imagine the possibility of hungry birds catching some in the air, so we might be able to see instants when "mabataki" meets "habataki."

※A play on the similar sounding Japanese words mabataki (blinking), and habataki (flapping).

まばたき と はばたき

時 間 を 測 る ス プ ー ン

Spoon to Measure Time

2004
2 × 12 × 4 cm

素材: ガラス
Material: Glass

計量スプーンの底に穴を開けると、すくった粒子がその瞬間からこぼれはじめて、
時間を計量するスプーンになることに気づきました。はじめは10秒、20秒、30秒と、
時間を正確に計量するつもりでしたが、粒子の大きさや湿度の条件から、
どうしても正確に測れないことがわかりました。逆に、時計とは違う砂の時間の
測り方を見つけました。すくった砂に固有の「スプーン一杯」の時間です。

By making a hole in the bottom of a measuring spoon, grains of sand start
flowing through the instant they are scooped up. It occurred to me that
such a spoon could be used to measure time. At first I thought it would be
an easy way to accurately measure 10 seconds, 20 seconds, 30 seconds,
but I found out that the size of the grains of sand and humidity conditions
prevented accurate time measurement. I made the opposite discovery that
measuring time with "sand" was different from measuring time with a clock.
This is the unique time of "one spoonful" of whatever type of sand is scooped up.

Spoon to Measure Time

近所の公園の砂とサハラ砂漠の砂ではスプーン一杯の時間が異なってきます。
地球上のあらゆる砂の粒子に内在する「時」を現在に解き放つスプーンです。
すくったその一杯の時間、そのときしかない時間が、すくった瞬間から流れはじめます。

The times of one spoonful of sand from a nearby park and one spoonful
of sand from the Sahara Desert are different. The spoon unlocks
the "times" inherent in all of the grains of sand on earth.
The unique time of a certain type of sand begins to flow the instant
one spoonful of it is scooped up.

Spoon to Measure Time 130 | 131

スプーンの構造を地球にたとえると、北半球のてっぺんが落下して赤道で裏返り、
南半球へとつながる時空を貫いたかたちをしています。北半球の人と南半球の
人が突然出会ってしまう程の出来事がこのスプーンの中では起こっているのです。

If you compare the structure of the spoon to the earth, it is shaped as if
the northern hemisphere fell and turned upside down at the equator,
traveling through time space to connect with the southern hemisphere.
Something is happening in the spoon as dramatic as people
in the northern and southern hemispheres suddenly meeting.

Spoon to Measure Time 132 | 133

キャベツの器
Cabbage Bowl

| 2004 | 素材: 紙粘土 |
| 15 × 20 × 20 cm | Material: Paper Clay |

本物のキャベツを型どりした型に紙粘土を貼りつけ、乾燥させて
とりはずすと、本物と同じようなしなやかさのある、まるで抜け殻のような
白いキャベツの葉が現れました。一枚ずつが皿になり、何枚か集めると
結球したキャベツになります。

A mold made from a real cabbage leaf is coated with paper clay and the clay is dried and peeled off. The result is a white cabbage leaf that looks exactly like a leaf cast off from a real cabbage and is just as pliable as a real one. Each leaf becomes a dish; putting the dishes together makes a head of cabbage.

キャベツの葉に水が溜まっているのを見かけたのがきっかけで、
そこにはもともと「器」がひそんでいたことに気がつきました。
キャベツの葉の形は、生産や調理に便利なように品種改良で
「デザイン」されてきたといいます。この器が思った以上に収まりよく
重ねられたことに納得がいきました。

Once I happened to see drops of water on the leaves of a head of cabbage and noticed that there is a "dish" originally hidden in cabbages. They say the cabbage leaf was "designed" by developing varieties that could be conveniently grown and used in cooking. That made sense to me when I discovered how easily the leaves could be layered over each other.

Cabbage Bowl 136 | 137

Cabbage Bowl

制作中、毎日のようにキャベツの葉脈を見ていたら、自分の手のひらが
キャベツの葉のように見えてきました。手のひらとキャベツのあいだから
「器」という共通の機能も透けて見えてきました。

During production of the work, I was looking at cabbages leaf veins
just about every day; eventually the palms of my hands starting looking to
me like cabbage leaf veins. Between my hands and the cabbages,
I also could see the transparent presence of their mutual function as a "bowl."

Cabbage Bowl

木 の 葉 の 座 布 団

Zabuton of Leaves

| 2004
葉／Leave:
5×3×0.03cm | 素材: 紙
Material: Paper |

紙と枯葉がそのしなやかさや手触りにおいて近い性質を
持っていることに気がつき、紙で葉っぱをつくりました。
枯れ葉を寄せ集めたときの感覚やその上に座ったときの
感触が見ているだけで感じられる座布団です。

I discovered that paper and autumn leaves are similar in the nature
of their pliability and texture, so I made autumn leaves out of paper.
By just looking at the zabuton you get the sensation of gathering
autumn leaves and the way it feels to sit on a pile of them.

※ The zabuton is a Japanese-style floor cushion.

本物の葉脈を置き換えた樹脂型とスーパーボールを使い、水で濡らした
紙をエンボスしてみました。すると乾燥するまでの間によじれや
歪みが自然に生まれてきたのです。その過程が自然界の木の葉が
乾燥し枯葉となる様子と重なっていることに気づきました。

Using a resin mold of a veined leaf as a substitute for a real leaf,
I embossed leaves on wet paper by pressing it on the resin with a super ball.
The paper becomes crinkly and misshapen naturally as it is drying.
I noticed that this process partly coincides with the drying up and withering
of tree leaves in the natural world.

Zabuton of Leaves 144 | 145

はじめは紙の清潔さとクッション性に着目して、贈り物を包む「緩衝材」にならないかと考えていました。でもある時、大量の葉が四角形にかたちづくられた様子が「座布団」のように見えてきて、まずは人間のための緩衝材になりました。

At first I focused on the cleanliness and cushioning property
of paper as a good buffer material for wrapping presents.
But when I happened to see a bunch of the leaves lying on the floor
in a square shape, I decided they would be a good buffer for people.

1枚1枚手づくりで葉っぱをつくっていたら、手と葉が似ていることに気づきました。それに気づいてしまったら、無数の手のひらが落葉している奇妙な風景が頭に浮かびました。

In the long process of making all of those leaves one at a time,
my hands started looking to me like leaves.
I got a weird mental picture of hundreds of hands falling from a tree.

ファスナーの船

Ship of the Zipper

2004
ラジコン／Radio Control:
25 × 60 × 20 cm
船／Ship:
300 × 1137 × 465 cm

素材: ラジコン／繊維強化プラスチック、モーター、
ラジオコントロールユニット 船／漁船、発砲スチロール、
ウレタン塗装、繊維強化プラスチック
Material: Radio Control／Fiber Reinforced Plastic,
Motor and Radio Control Unit
Ship／Fishing boat, Foamed Styrol,
Urethane Paint and Fiber Reinforced Plastic

飛行機の窓から東京湾を見下ろしたとき、海を進む船と航跡がファスナーのように見えました。それをきっかけにラジコン式のファスナーの船をつくり、公園の池の水面を「開き」ました。本物と違うのは、常に進むルートが決まっていないこと。

Gazing down on Tokyo Bay from an airplane window, the ships and boats moving over the water and the track of waves they left looked to me like zippers. It gave me the idea to build a radio-controlled ship in the shape of a zipper tab, which I used to "unzip" the lake in the park. The difference from a real zipper tab is that it doesn't always proceed along the same route.

Ship of the Zipper

アンテナ
バッテリー
モーター
スクリュー
舵
サーボモーター

ファスナーの船の力学

Ship of the Zipper

いつか人が乗れる巨大なファスナーの船をつくって大海原を切り開き、その様子を
山や上空からみんなで見てみたいと思っていました。そして2010年、瀬戸内国際芸術祭を
舞台に海を開くチャンスが到来しました。芸術祭への参加には「人が乗れる」という
条件が求められ、厳しい船舶の検査を通過する必要がありましたが、多くの
人の協力によって、全長11.37メートル、重さ5.3トンのファスナーの船が実現しました。

I got to thinking that I'd like to build a giant zipper tab that people could ride in and zip open the ocean, which I'd want to watch with everyone from the mountains or from the air. At the Setouchi International Art Festival 2010, I got the opportunity to zip open the ocean. In order to participate in the art festival, they made the condition that people would be able to ride in the ship, so it had to pass a strict ship inspection. Thanks to the efforts of a great number of people, we built a zipper tab 11.37 meters long weighing 5.3 tons.

上空からの視点

サンポート高松展望台

島展望台　　「ファスナーの船」　高松港　　高松駅

船内の座席の配置は、限られた空間を有効に活用するために「お見合い席」にしました。すると向かい合って座った人と偶然足が交互になり、ファスナーの嚙み合う金具のように見えて、思わず互いに笑いました。ファスナーの船の船内は、開く直前のつなぐ空間でもあることに気づきました。

Seats on the ship were placed facing each other in order to make optimum use of the limited space, so people sitting opposite each other naturally put their legs in alternating directions. When we noticed that our legs resembled the alternating teeth of a zipper, we all laughed. I discovered that the interior of the Zipper Ship was also the zipped up space of the zipper before it is unzipped.

ファスナーの留め具が人の形に見えてきた

Ship of the Zipper

さらに大きな旅客船に拡大して外海を開くことを夢見ています。
あるいは、小型のボートをつくり、澄んだ湖を静かに開いてみたいと思っています。
大陸の内側と外側、双方から地球を開いていくイメージです。

I also dream of constructing a big passenger ship that unzips the high seas.
Or of building a small boat and quietly zipping open a clear lake. I have the images
of opening the earth from the interior and exterior of continents.

Ship of the Zipper 168 | 169

Photo: Kawauchi Rinko

水 の 素 質

Propety of Water

2004 オブジェ／Object： 70×45×45cm 鏡／Mirror： 180×180×0.5cm	素材: スチール、鏡、モーター、プロジェクター、 DVDプレーヤー Material: Steel, Mirror, Motor, Projector and DVD Player

しずく型に成形したワイヤーを暗闇の中で回転させ、波紋や水面など、水のふるまいを表現した映像を投射します。回転体のうみ出す微かなブレが光線と交わる瞬間、水面の揺らぎのような現象がうまれました。揺らぎによって表現されたしずくの質感が、見る人それぞれの記憶の中の「水」を呼び覚まします。

Wires in the shape of a water drop rotated in the darkness create a screen on which images are projected that express the behavior of water in its various forms — ripples, water surfaces. At the instant when the slight wobbling of the revolving object intersects with light rays, a phenomenon resembling a rippling water surface is created. The appearance of a water droplet suggested by this undulation revives the viewer's personal memories of water.

床には水を2センチ張っています。中に踏み入らないようにするための
自然な結界であるとともに、空間に与える湿気など、その生な感じが
実は重要な役割を果たしていたように思います。

The floor is covered with water two centimeters deep. It acts as
a natural barrier that prevents people from entering the installation space
and also imparts moisture and the real feel of water to the installation space,
all of which I think is a very important part of this work.

鏡　　鏡

水鏡

Propety of Water

Photo: Kawauchi Rinko

光が届く限り、無限に連なる合わせ鏡の空間は、しずくが反転を繰り返しながら
見る人の視線を奥へと導いていきます。遠ざかりながら、同時に目の前の
一つのしずくに収斂する、内省的な空間です。いつまでも見てしまうのは、
繰り返し投影されるパターンではなく、二度とは起こらないその瞬間の揺らぎ
を見ているからだと思うのです。自分の頭の中にある「水」を探し当てる
感覚と言えるかもしれません。

As long as light shines on the work, an endless space is created by mirrors combined to repeatedly reflect the water droplet; this draws the viewer's gaze into the distance. The space is introspective because while the viewer is gazing further into the distance the eye also converges on the water droplet directly in front. I think people stand looking at the installation for a long time not because of the repeated projection of patterns on the screen but because they are waiting for the instant of undulation which never occurs twice in the same way. Perhaps it could be described as searching for the "water" in their memory.

Propety of Water

しずくのぷるぷるとした揺らぎと、線香花火が似ていることは
後から気がつきました。水と火というかけはなれたものも、
頭の中では同じになります。

It was only later that I noticed the similarity between the quiver
of the water droplet and the tiny drop of fire on the end of a sparkler.
The mind puts the entirely different elements water and fire
in the same category.

う し ろ 姿 の 模 型

Figure of the Back View

2004
44 × 12 × 12 cm

素材: 写真、木材、モーター
Material: Photograph, Wood and Motor

自分のうしろ姿の写真を表裏に貼り合わせて回転させます。
そうすると、正面を見ようと回り込んでも常にうしろ姿しか見ることができません。
360°どこから眺めてもうしろ姿に見える奇妙な立体が現れました。

I took two pictures of the backside of myself, glued them together, and spun them around. Anyone who walks around it trying to see me from the front will still only be able to see my backside.
From any point 360 degrees around it, you can only see the backside of this weird three-dimensional figure.

三面図で表現すると、側面図がもっとも魅力的。
回転中に側面で像が一瞬消えるため、
うしろ姿の像がどこから見ても正対して見えるのです。

Expressed in terms of front, back, and side views, the most
attractive view is the side view. Because the figure disappears for
an instant at the side view when it is spinning around,
my backside is seen directly from the front from any position.

Figure of the Back View

この像を眺めていると、目の前にありながら、自分のうしろ姿が遠ざかっていくような印象を受けます。また、暗黙のうちに反対側の自分の視点をつくりだしていることに気づきました。

As I gazed at the figure, I got the impression that my backside was moving into the distance. Implicitly, I noticed that I had created another perspective that let me see myself from the back.

Figure of the Back View

今は鏡やカメラなどあらゆる姿見のテクノロジーがありますが、
おそらく大昔の人たちは、水を垂直に立てない限り、
自分のうしろ姿を自分の目で確かめることはできなかったはずです。
もしかしたら、うしろ姿は人間にとって本来見てはいけない
領域だったのかもしれません。

Today we have mirrors, cameras, and a variety of other technologies
that let us see ourselves. Unless they could stand vertically
on the water, people of long ago probably weren't able to see their
backside. It might be that one's backside is forbidden
territory people were never meant to see.

ろうそくは溶けて燃料になるとともに、溶けたろうを溜めておく皿でもあります。
「皿」が3つもある、けん玉のろうそくをつくりました。はじめは平らな部分に火を灯すと、
玉を受け止める皿が現れて、けん玉が完成します。

When a candle melts it becomes fuel and also a dish for holding melted wax. I used a candle to make a kendama that has three "dishes." Lighting the part of the candle that is originally flat causes a dish for receiving the ball to appear — the kendama is complete.

けん玉の蝋燭

Candle of a Kendama

| 2004 | 素材: 蝋、ひも |
| 19×7×7cm | Material: Wax and String |

けん玉には赤い玉を炎に見立てる「ろうそく」という技があります。火を灯して少し長めの露光で撮影したところ、炎から放射状に広がる光が「球体」となって写りました。肉眼では見えないその事実を「ろうそく」という技は正確に見立てていたのです。

This kendama uses a "candle" trick to liken the red ball to a flame. Filming the lit candle at slightly longer exposure than usual produced an image in which the light emitted by the flame appeared as a sphere around it. Although this phenomenon can't be seen with the naked eye, the flame is precisely likened to a red ball by the "candle" trick.

Candle of a Kendama 188 | 189

スプーンの蝋燭

Candle of the Spoon

2004
12×4×2cm(L)
11×3×1.5cm(M)
10×2×1cm(S)

素材: 蝋
Material: Wax

火を灯すことでゆっくりと窪みができてスプーンになります。
そう予想してつくったところ、液体まで現れました。
自分でも気づかないうちに、どこからかすくいとってきたような
気分になりました。

I imagined that if a candle in the shape of a spoon was lit, it would form
a depression that would gradually deepen. I made one and it worked like
I had thought; liquid even appeared in the depression. Before I realized it,
I felt myself wanting to use the spoon to scoop up something.

炎を垂直に保ち、ろうがこぼれ落ちないよう平衡を保つ
無意識のはからいは、普段スプーンを持つ指先の感覚と
自然につながっていました。

The unconscious act of maintaining equilibrium
— keeping the flame vertical so the melted wax wouldn't
run out of the spoon — naturally resembled the sensation
in the fingertips when holding a normal spoon.

？のあめ
? Candy

2005 2.3 × 10 × 18.5 cm	素材: プラスチック、あめ玉 Material: Plastic and Candy

あめが容器から飛び出した「瞬間の形」を活かしたあめの
パッケージをつくりました。?マークの「ん?」というニュアンスが、
この容器からあめが出る寸前の気分と一致しました。

I constructed a candy package that plays on the "instantaneous shape"
made when the candy shoots out of the package.
The "Huh '?'" nuance embodied by the ? mark matches the way
you feel the moment before the candy comes out of the package.

正面から見ると「はてな」のかたちですが、90°回転させると「びっくり」の形になります。
「なんだろう？」と思いながら、あめが出た瞬間、端から見ると「びっくり」に見えます。
「はてな」と「びっくり」は、同一のものの「側面」を表現した記号なのかもしれません。

Seen from the front, the candy package has the shape of a question mark,
but when rotated 90-degrees it takes on the shape of an exclamation point.
As you are thinking "What's that？," the instant the candy comes out the package
looks like an exclamation point when seen from the side.
Maybe the question mark and the exclamation point are symbols that
express two sides of the same thing.

紙マッチの図柄を火にしました。
火をつけると、火の画像に本物の火が重なって
「炎」という文字になるのではないかと考えました。

I designed a paper match in the shape of
the Japanese kanji 火 (fire). When the match is lit
and this real fire is placed over or under the image
of 火, it produces the kanji 炎 (flames).

炎 の マ ッ チ

Matches of Flame

2005	素材: 紙、マッチ
0.5 × 4 × 5cm	Material: Paper and Match

燃えるという根源的なイメージを記号化した「火」という文字を
もう一度現象に還してみようと思いました。火を軽々と再現できるマッチ自体が、
映像再生機のようなものに感じられました。

I wanted to return the kanji 火, which only encodes the fundamental image
of burning and is not the real thing, back into the actual phenomenon of burning.
I perceived the match itself, which can reproduce fire so easily, as approximating
something that could be described as image reproduction equipment.

火は手には持てないもの

Matches of Flame

自分の目を撃つ

子供の頃どうしても目薬をさすことができなくて、いつも指先がふるえました。
ふとそのことを思い出し、目薬の怖さは自分自身に銃を向けるような
感覚ではないかと思いました。ねらう「的」は自分の目。目薬は「的」が見えないから
むずかしいのではないかと思いました。

When I was a kid I just couldn't seem to put eye drops in my eyes;
my hands always shook. Once, for no particular reason, I happened to recall that.
Looking back, I think I was afraid of eye drops because it felt like I was pointing
a gun at myself. The target was my eye. I guess I found it difficult to put eye drops
in my eyes because I couldn't see the target.

目　薬　の　銃

Eye Dropper

2005
1.4 × 8.3 × 5.3cm

素材：プラスチック、目薬
Material: Plastic and Eye Lotion

空気

目薬

空中で水の球になる

的

目薬が空中で球体になり、まさに鉄砲の弾のようです。そこに景色が映り込み、
景色もろとも目の中に飛び込んできます。容器の制作中、シンクに水を溜めて水滴を
落としていたところ、同心円の波紋が「的」に見えました。水滴の弾が確実に
中心を打ち抜いているような感覚になり、百発百中の鉄砲を手にしたような気分です。

An eye drop becomes a sphere in the air that it really looks like a gun bullet.
Scenery is projected on the eye drop sphere and the sphere and scenery
all shoot into the eye. During the process of constructing the container, I filled
the sink up with water and dropped a drop of water in it. The concentric circle
of ripples produced looked like a "target." After I did that for a while, I began
to get the sensation that the water drop bullet was penetrating at dead center.
I felt like I had found a gun which would hit the target every time.

気 配 の ク ッ キ ー
Cookies Sensed But Not Seen

2005	素材: 小麦粉、バター、卵、砂糖、アルミニウム
0.5×6×6cm	Material: Flour, Butter, Egg, Sugar and Aluminium,

はじめからかじられた跡のあるクッキーです。伸ばした生地から型で
どんどんかじり取っていくとクッキーどうしのすきまが余ります。
その余ったところを集めて伸ばし、またかじり取る過程が何ともいえず
気になっていました。

A cookie with a bite already taken. When the dough is rolled out and
lots of cookies are bitten out with a bitten off cookie cutter, dough is left
between the cookies and the left over dough is gathered up, rolled out,
and more cookies are bitten out. I found this process very curious.

Cookies Sensed But Not Seen

あったはずのものが別のものになり、さらにそこにあるはずのものが
また別のものの一部となっていく、あらかじめかじられた、目に見えない存在によって、
同じ生地からできたクッキーすべてが関係しているように感じられました。

> Something that should be there becomes something else, and
> that thing becomes part of something else; I felt that all of the cookies
> made from the same cookie dough are related because of
> this invisible presence bitten off in advance.

クッキーはかじられるとその人の一部になって形を消します。
と同時に「気配のクッキー」がうまれているように感じました。
食べれば食べるほど、目に見えないクッキーが増殖していきます。

 Take a bite out of a cookie and the shape of the piece bitten off disappears
and becomes part of the person that eats it. But I ended up looking at it
the other way around — biting off a cookie brought into existence a "cookie sensed
but not seen." The more cookies eaten, the more invisible cookies multiply.

Cookies Sensed But Not Seen 210 | 211

自 画 像 の パ ズ ル

Self-Portrait Puzzle

2005
1 × 15.5 × 33 cm

素材: アクリルミラー、木材
Material: Acrylic Mirror and Wood

鏡のジグソーパズルです。そのとき映り込んだ像がパズルの図柄になる難解なパズル。バラバラになったかけらの一つ一つに映り込む像は、自分の視点に固有のものであり、組み立ての複雑なプロセスの結果として自分の顔が現れてくるのです。

This is a mirror jigsaw puzzle. My reflection in the mirror at the time is the design of this difficult puzzle. My image reflected in each of the separate pieces is specific to my line of sight and the result of the complicated process of assembly is the appearance of my face.

パズルは1ピースずつはめていくしかなく、その間に刻一刻と変化する自分の視点や
まなざしそのものが、自画像をかたちづくっていきます。はじめバラバラの景色は、
形がピタリとおさまる瞬間、そこに映る像も一つに統合されていきます。

I can only put in one piece of the puzzle at a time; while I'm doing this,
the moment by moment change in the direction of my gaze and the expression of
my eyes shapes my self-portrait. At the moment when the fragments of the scene
come into just the right shape, the image reflected there is consolidated.

Self-Portrait Puzzle

水 平 線 の 消 息 ― 色 鉛 筆

Note from Sea Horizon ― Colored Pencils

2005
0.8 × 17 × 0.8 cm

素材: 色鉛筆、接着劑
Material: Colored Pencils and Glue

海がしけ、空は曇りだったとき、水平線が消えるのを見たことがあります。
水平線は空と海の色彩のバランスによって現れ、天候によって常にうつり変わっていく
動的な「線」であることに気づきました。

I've watched the sea horizon disappear when the sea was rough or the sky was cloudy. I discovered that the sea horizon appears with the right balance of the shades of sky and sea, and is a dynamic "line" that constantly changes depending on weather conditions.

「消息」という言葉には「息＝生きる」、「消＝死ぬ」という二つの概念が
同居しています。正反対のようですが、両方あってはじめてそこに
立ち現れるものを表現しているようです。この言葉の印象が海岸から
臨む水平線の印象と重なってきます。

In the Japanese word 消息 (shosoku), the two concepts 息 (being alive) and
消 (being dead) are paired together. They are direct opposites;
however, it is only when they are both there that they express what appears.
The impression made by this word coincides with the impression of
looking out at the sea horizon from the shore.

※ Shosoku is a word used to refer to the state or condition
of a person or entity: for example, whether some is alive or dead,
developments in political affairs, or news of someone.

Note from Sea Horizon — Colored Pencils

水 平 線 の 消 息 ── ひ も

Note from Sea Horizon ── Rope

2005
215 × 340 × 120 cm

素材: ビニールケーブル、ステンレス・スチール、モーター、スライダー、プロジェクター、DVDプレーヤー
Material: Vinyl Cable, Stainless Steel, Motor, Slider, Projector and DVD Player

16本の白いひもが回転し、残像のスクリーンを描き出しています。
そこに空と海の映像を投影しました。スクリーンは、回転しながら幅を狭めて
また開く、ビュンビュンごまのような動きを繰り返しています。

Sixteen strands of white rope spin around to depict a screen of afterimages.
I projected images of the sky and the sea on the screen.
As the screen revolves its width narrows and opens in a repetitious
movement similar to that of a spinning color wheel.

スクリーンの変化で、風景がだんだん横に扁平になり、水平線に近づいていきます。
反対に、縦にも伸びて扁平になり水平線が消えます。実体がなく、連続性の中で
現れたり消えたりする、抽象的な「水平線」を表現しています。

The changing screen movement causes the scenery to gradually flatten out
on the side, nearing the horizon. Conversely, it also stretches vertically
and flattens so that the horizon disappears. The work depicts an abstract horizon
without substance that appears and disappears within continuity.

Note from Sea Horizon — Rope

ある時、スクリーンを見つめる視線の果てには本物の水平線や地平線が
あることに気がつきました。映像を見ているのではなく、現実を透かし
見るような感覚です。地球上で水平線を見つめる大勢の人の無数の視線が
もうひとつの地球の輪郭を描き出しているイメージが頭に浮かびました。

One time when I was gazing at the screen, I became aware that the real sea
and earth horizons were at the end of my line of vision. It was a sensation of
looking not only at the images, but of seeing through to reality.
The image came to mind of a multitude of people on earth gazing at the sea
horizon whose countless sight lines drew the outline of another earth.

りんごの天体観測

Constellation of Apples

2006
38×49×49cm

素材: プラスチック、鏡、LED、モーター、電球、木材、スチール
Material: Plastic, Mirror, LED, Motor, Electric Light Bulb, Wood, and Steel

りんごの表面にある無数の斑点が星座のように見えました。中空のりんごの
模型をつくり、表面に無数の小さな穴を開けて光源を仕込みます。すると穴から
細い光が放射され、回転するスクリーンに無数の星々が浮かび上がりました。

The hundreds of spots on the skin of an apple looked like stars.
I made a model of an apple in space, put hundreds of tiny holes in the skin,
and illuminated the apple from inside. Light radiated from the holes
and countless stars appeared on the revolving screen.

ハンドルを回すことで8本の細い帯が回転し透明な半球のスクリーンになります。
放射された光の断面が残像となって空中に浮かび上がります。星座はそれぞれ別の瞬間に
発せられた光が人の網膜に同時に到達したもの。宇宙空間を立体的に突き進み、
人の網膜のスクリーンに浮かんだ光の断面なのです。

When the handle is turned, eight thin bands revolve to form a transparent semispherical screen. The cross-section of the light radiated becomes afterimages that float in the air. Light emanated from the various constellations at separate moments reaches the eye simultaneously. It's a slice of light that travels from different directions through space and appears on the screen of our retinas.

太古から変わらないように見える星座の配置も、地球というひとつの
視点に固有のもの。そして地球上の無数の視点の一つが「僕」で
あるという認識。これまで地球上にうまれ落ちたりんごの中に
一つ一つの視点があり、星を眺める人たちと同じくらいの特別感を
もって存在しています。

The positions of the constellations, which don't seem to have changed
since ancient times, are perceived by us specific to earth's vantage point.
And the recognition that I am one of those millions of vantage points on earth.
Each one of all the apples that have grown and fallen on earth until now
also have a unique vantage point and individuality, just as all of
the people who gaze at the stars do.

今見ているのは、地球上にある無数のりんごのどれか一つから
放たれた星空かもしれません。それをみつけて食べてしまったら、
星空は消えてしまうのではないかと妄想を膨らませました。
これまで地球上に生まれたりんごの中に、地球から眺めた星座と
同じ「星座」をもったりんごがあったかもしれません。

What we see now might possibly be the starry sky emitted by one of the apples on earth. I stretched my imagination to wonder what if someone finds that apple and eats it — would the stars vanish from the sky? Of all the apples that have grown on the earth until now, it could be that there is one apple with exactly the same pattern of stars that we see from earth.

Constellation of Apples

スープが残りわずかになると、無意識にお皿を少し傾けたくなります。ある時、お皿の隅にのこったスープが三日月に見えました。スープ皿の底をあらかじめ傾けて、断面の形状を絶妙にコントロールすれば、その時々のスープが月の満ち欠けのように見えるのではないかと考えました。

When there isn't much soup left in the bowl, we unconsciously tip the bowl. Once, when I did that, the soup left in the corner of the bowl looked to me like a crescent moon. It gave me the idea of tipping the bottom of the soup bowl on purpose to finely control the shape of the cross section so that the soup would appear to wax and wane like the moon.

スープの満ち欠け
Phases of Soup

2006
4 × 23 × 23 cm

素材: 陶器、コーンスープ
Material: Pottery Bowl and Corn Soup

full ⟶ empty

full
empty

スープの月も本物の月も同じように地球に引かれています。スープ皿の
底を這うように変化していくスープの形を眺めていると、潮の満ち引きなど、
月と地球の引力の関係を連想しました。

The soup moon and the real moon are attracted in the same way
by the earth. As I watched the changing shape of the soup which seemed
to crawl over the bottom of the bowl, I associated it with
the gravitational force that operates between the moon and the earth
causing the rising and falling tides.

月

皿

地球

Phases of Soup 240 | 241

蛇口の起源

The Origin of the Word "Jaguchi"

| 2006 | 素材: 蛇口、水 |
| 不定形／Irregular | Material: Tap and Water |

蛇口という漢字が急に頭に浮かんで、はじめに名前を決めた人は、
水道口から流れ出た水がヘビに見えたのではないかと思いました。
しかし、そういう事実は見つけられませんでした。

The kanji 蛇口 (jaguchi) suddenly sprung to mind. I concluded that to
the person who decided on this name, water coming out of a faucet
must have looked like a snake. But I couldn't find any evidence to support it.

※The Japanese word jaguchi, meaning water faucet,
combines the kanji 蛇 (snake) and 口 (mouth).

公園で蛇口の角度やひねるタイミングなどいろいろ試したところ、
かなりヘビらしく見えてきました。川も「蛇行」するといいますし、ヘビが地面を
移動する様子はよく見るとまさに水のようです。

I tried adjusting the angle and timing the water came out of a water faucet in the park; I was successful in getting the water to look pretty much like a snake. We say a river "winds" or "snakes" (the word in Japanese, jako, is written with the kanji 蛇 (ja, snake) and 行 (ko, go). Watch closely as a snake moves over the ground; the resemblance to water is striking.

The Origin of the Word "Jaguchi"

空気に溶けるような繊維と形容されている極薄の繊維の魅力を
引き出すために、空気よりも軽い人体を制作しました。ヘリウムガスの
浮力と繊維の重さとのバランスに着目し、空中で絶妙に釣り合う
体勢を探しました。

I made a human figure lighter than air to give maximum expression to
ultra super-thin fiber that has been described as being so light that it seems
to melt in the air. I focused on the balance between the buoyance of
helium gas and the weight of the fiber and tried out all kinds of physical
postures for the figure searching for one that would facilitate perfect
counterbalance of the helium and fiber in the air.

空 気 の 人
Aerial Being

2007
190 × 60 × 90 cm

素材: プラスチックフィルム（HEPTAX）、
ヘリウムガス、空気
Material: Plastic Film（HEPTAX）,
Helium and Air

常に人体の浮力の分だけ繊維が離陸し釣り合うようになっています。繊維は人体を
地面につなぎとめる命綱であるとともに、その生命力を示す指標になりました。
ヘリウムガスはミクロン単位の隙間からゆっくりと抜けていきます。しだいに生気を失い、
人体が萎み、繊維も着地します。展示中、人がポンプでヘリウムを補給する様子が
何とも言えず不思議な光景でした。

The fiber trying to land counterbalances the human figure trying to float.
The fiber was both a safety rope that connected the human body to the ground
and a barometer of the human life force. The helium gas slowly goes out of
the micron-sized apertures in the balloon figure. It gradually deflates,
losing its life spirit. The fiber lands on the floor. While the figure was being exhibited,
I found the sight of someone pumping more helium into it indescribably strange.

Aerial Being 248 | 249

《空気の人》を全長12メートルに拡大して、羽田空港のロビーに浮かべました。ロビーに居合わせた人たちの呼吸する空気や、各地の空港から運ばれてくる空気をおへそに設置した電動ファンから吸い込み、膨らみ続けます。

I made figures based on the Aerial Being figure but expanded to a length of 12 meters and floated them in the lobby at Haneda Airport. The figure continues to expand via an electric fan attached at the navel that sucks in air breathed by the people present in the lobby and air brought in from airports in other locations.

Photo: Homma Takashi

バケツの切り株

Bucket Stump

2007 35×40×27cm	素材: 繊維強化プラスチック、アルミニウム Material: Fiber Reinforced Plastic and Aluminium

切り株形の容器に溜まった水面にしずくが落ちると、波紋が年輪に見えるのではないかと考えました。人間の時間感覚では動きとしてとらえられない木の生長も、時間のスケールさえ変えられたら、波紋のように瞬く間に広がっていくように見えるのではないかと想像しました。

It occurred to me that if a drop of water fell in a container shaped like a tree stump that was full of water, the resulting ripple pattern would resemble the annual growth rings of a tree. From our human time perspective, we can't see the growth of trees in terms of movement. However, if we could change the time scale, I imagine that the growth and multiplication of trees might appears instantaneous as the formation of the ripple pattern in the water.

バケツが完成し水を入れて持ち運ぼうとしたとき、重くて持ち上がりませんでした。いつの間にか地面に根を張ってしまったのではないかと思いました。通常、バケツは底面に向かって形状を細くすることで、入る水の量を抑えています。さらに、重心を高くして持ち運びやすくするといった、さりげない重要な工夫に感心しました。

When I tried to move the completed bucket filled with water, it was so heavy that I couldn't pick it up. I wondered when it had put roots into the ground. Ordinarily, the shape of a bucket is gradually narrower approaching the bottom to minimize the amount of water you can put in it. In addition, buckets are made to have a high center of gravity to make it easy to carry them. I found this inconspicuous ingenuity very impressive.

銀閣寺のチョコレート

Chocolate Ginkaku-ji

2007
6.8 × 7.2 × 6.3 cm

素材: プラスチック、アルミホイル
Material: Plastic and Aluminium Foil

金閣寺は金色なのに、銀閣寺はなぜ銀色ではないのかと誰もが思います。
金閣に対して、後に銀閣と名付けられたため、当初から銀色にする予定は
なかったとも言われています。銀閣寺が銀色でないことにみんな同じように
意表を突かれたことを思い出すきっかけをつくりたいと思いました。

Kinkaku-ji (The Golden Temple) is gold, so why isn't Ginkaku-ji
(The Silver Temple) silver? They say the temple was given the name Ginkaku-ji
only later after it was built in contrast to Kinkaku-ji, and that there was
never any intention of making it silver. I created this work to remind everyone
of the surprise they felt on discovering that Ginkaku-ji isn't silver.

Chocolate Ginkaku-ji

チョコレートといえば銀紙で包む物。そして気がつけば銀閣寺もチョコレート色でした。
模型をつくってから現物を見学したところ、本物には障子があることを
見落としていました。そこはホワイトチョコレートでつくろうと思いました。

Speaking of chocolate, everyone knows it's always wrapped in silver paper.
I found myself making Ginkaku-ji chocolate color. After I made the model
and went to look at the real Ginkaku-ji, I noticed that I had overlooked
its paper screen sliding doors. I decided to make them out of white chocolate.

Chocolate Ginkaku-ji

繊　維　の　人
Fiber Being

2009 185 × 55 × 30 cm	素材: プレスエアー、アクリル樹脂、エアシリンダ、 電磁弁、コンピューター Material: BREATHAIR®, Acrylic Plastic, Air Cylinder, Solenoid Valve and Computer

通気性とクッション性に優れ、座席やベッドなどへの用途が多いブレスエアー
という繊維。この繊維を見て頭の中に浮かんだのは、1本の繊維が自在にものを
描き出していくイメージ。この素材の三次元への志向をさらに次の段階に
高めたいと思い、立体整形に挑戦しました。

Breathair is a fiber with permeability and cushioning properties that
has numerous applications; for example, the production of seats and beds.
When I saw this fiber, I got a mental image of one fiber freely drawing
all sorts of things. I wanted to take this materials' preference for
three dimensions a step further by taking up the challenge of making
an actual three-dimensional object out of it.

Fiber Being

体の中心に向けてエアシリンダで引っぱり、ゆるめると繊維の
弾発力でもとに戻ります。体の至るところを次々とリズミカルに凹ませました。
いくら殴られても元に戻る不死身の身体といったイメージです。

The suit is pulled by an air cylinder toward the middle of the body
but snaps back into shape because of the resilience of the fiber.
The cylinder dents the suit rhythmically from one part of the body
to the next. The image is of an invulnerable body returning to
normal no matter how many times it's punched.

Fiber Being

Fiber Being 264 | 265

羽田空港の待ち合わせエリアに「針のない時計」を設置しました。コンピュータによる画像処理技術によって、時計を見ている人だけを検出し、その人のシルエットを切り抜き、時計の針として表示します。自分が針になってリアルタイムの時刻を表示します。秒針は毎秒、分針は1分に一度、時針は1時間で更新されます。

I hung a clock without hands in the rendevous area at Haneda Airport. Employing image processing technology, a computer detects only people looking at the clock; their silhouettes are cut out and displayed as a clock hand. They become clock hands that display the time in real time. The second hand is changed every second, the minute hand every minute, and the hour hand every hour.

自 針 と 分 針

People Hand and Minute Hand

2009	素材: スチール、アクリル樹脂、液晶ディスプレイ、コンピューター、カメラ
125 × 90 × 50 cm	Material: Steel, Acrylic Plastic, LCD, Computer and Camera

Photo: Morimoto Mie

公共の時計に自分の姿が映ることで「時間」や「時刻」を自分の身体を
軸にとらえ直すことができると考えました。時計という機械的なものも、
それを見る人がいてはじめてその存在に魂がこもるのではないかと思います。

I got the idea of having people's silhouettes appear on a clock in a public space
so that they could gain a new perception of time and the time of day in terms of
their own body as the point around which time revolves. I regard the clock
as a mechanical object that becomes something embodying a soul
only if there are people to look at it.

People Hand and Minute Hand

木 の こ ま

Spinning Top Trees

2010	素材: 木材
4 × 2.5 × 2.5 cm	Material: Wood

逆さごまがひっくりかえった体勢を木の形に見立てました。木は地球上に
長い時間じっと立っているように見えますが、時間のスケールを地球のスケールに
置き換えてみると、木が立っている時間は束の間の出来事かもしれません。
木の時間をあらためて意識しました。

I conceived of the shape of a tree standing to approximate an upside down
spinning top that turns right side up. Trees look as if they have been standing on
the earth for a long time, but if our time scale is switched to earth's time scale,
perhaps trees have been standing for only a moment. This work gave me
a renewed consciousness of tree time.

木　　　　林　　　　森

1本立つと「木」、2本立つと「林」になり、3本立つと「森」になります。
3本を同時に立てるのはとてもむずかしく、3本目が立った瞬間に1本目が
倒れてしまうのです。「森」が成功して喜んでいる暇はないのです。
木を植え続けることの大変さを疑似体験しました。

One standing is a "tree," two standing are "woods," three standing are
a "forest." It's extremely hard for three to stand up simultaneously;
the instant the third tree stands up, the first tree falls down.
There's no time to be glad about the success of growing a forest.
I had the virtual experience of how hard it is to keep planting trees.

空気を詰め込み、持ち運ぶための鞄です。普段生活している環境から
遠く離れた旅行先の空気や、特別な日の空気など、空気を時間と空間から
切り抜いて移動させる鞄です。

A luggage bag for packing and carrying air. All sorts of air
— for example, air in travel destinations far from the environment
we live in or air on special days — can be cut out from time and
space and transported in this luggage bag.

空 気 の 鞄
Aerial Luggage Bag

2010	素材: 塩化ビニールシート
32 × 25 × 10cm	Material: PVC Sheet

空気注入口

ポケット

鞄には日付とサインを入れます。外側についている奥行きのない
ポケットに記憶の目印となる物を入れておくことで、いつの日かその時の
記憶が一層よみがえるはずです。

A date and name are put on each bag. If objects for marking memories
are put in the outside pocket, which has no depth, someday the memories
of those times will come back with greater clarity.

Aerial Luggage Bag

募 金 箱 「 泉 」
Donation Box Called Well

2011
スリット／Slit: 6 × 0.4 cm

素材: ミクストメディア
Material: Mixed Media

募金箱を「箱」の形から考えるのではなく、美術館そのものを
募金箱に見立てました。コインを自分の「分身」としてとらえ、
壁面にスリットを施し、美術館の活動への新たな入口をつくりました。

I never considered a "box" shape for the donation box; I wanted to
make the museum itself the donation box. I thought of the coin donated
as the alter ego of the donator. I made a slit in the museum wall as
a new sort of entrance for museum activities.

Donation Box Called Well

コインを投入するとコインの落ちる音は消え、水滴が落ちた音が響きます。
入れたコインの種類によって水滴の音が異なります。
スリットをのぞくと美術館の敷地内の木漏れ日や水面に映る揺らぎの
映像がぽっかりと浮かんでいます。

When a coin is dropped through the slit, the metallic sound of
the falling coin is replaced by the sound of a water droplet falling into
a pool of water. The sound of the water droplet varies with the type
of coin donated. When you peek through the slit, you see drifting
images of light filtering through the trees in the museum grounds
and rippling reflections on a water surface.

Donation Box Called Well

まばたき採集箱
Specimen Box of Blinking

2011 12 × 17 × 8cm	素材: 木材、デジタルカメラ、金網、バンド Material: Wood, Digital Camera, Metallic Mesh and Band

目を開いた写真、閉じた写真を貼り合わせて回転させると顔写真が「まばたき」をしているように見えます。まばたきという現象が生き物のように感じたのがきっかけで、カメラを昆虫採集の虫かごのような「採集箱」に改造し、出会った人の「まばたき」を採集しました。

Photographs of people's faces with their eyes closed and open are glued back to back and spin around so that the people appear to be blinking. The phenomenon of blinking feels to me like something that is alive, so I came up with the idea of converting my camera into a specimen box to collect the "blinks" of people I met, like the insect cages people use to collect insects.

標本箱もまた世界を切り取る装置です。すべては収集できないことを
わかった上で、むしろ自分の手が届く限られた範囲の中で採集できた
「世界」にこそリアリティを感じました。最近は、採集するたびに「目を
閉じる時間」をつくっているのではないかと意識するようになりました。

The specimen box also cuts away parts of the world. I know
I can't collect it all; but still I sense the reality of the "world" in
the limited microcosmos I am able to collect. Recently, every time
I collect specimens, I've become aware that perhaps I'm making
"time when people can close their eyes."

まばたきの標本 Specimens of Blinking 2001

まばたき証明写真

Blinking ID Photos

2011 208 × 120 × 80 cm	素材: 木材、蛍光灯、鏡、コンピューター、カメラ Material: Wood, Fluorescent Lamp, Mirror, Computer and Camera

まばたきを検知して、自動的にシャッターを切る証明写真機です。
画像認識の技術によって、その人が目を閉じているか開いているかを
リアルタイムに認識しています。

This is ID photo equipment that automatically clicks the shutter
when it detects a blink. Employing image recognition technology,
it detects in real time whether the person's eyes are open or closed.

Blinking ID Photos

証明写真は社会の中で「本人」であることを証明するために必要とされています。
昔は写真館でカメラマンのおじさんが人と向き合い、その人らしさを見つけるように
撮影をしました。今は街の中に設置された無人の証明写真機を「鏡」にして、
自分自身で撮影するようなしくみになりました。

Society considers ID photos to be necessary in order to verify people's identities. In the past, the guy in a photo studio made an effort to take pictures that would express the personality of the subject. Now, the unmanned ID photo equipment installed around town functions like a "mirror" and you take your own picture.

Blinking ID Photos

日本列島の方位磁針
Compass of Japanese Islands

2011 1.6 × 6 × 6 cm	素材: アルミニウム、ステンレス、ガラス Material: Aluminium, Stainless and Glass

方位磁石の針を日本列島の形にしました。すると、今自分が立っている
日本列島の方角が東西南北という情報を経由せずに直感的にわかります。
実際に手のひらにのせてみると、今まで感じたことのないリアリティを
もって日本の方位を感じました。針の中心はちょうど富士山のポジション。
富士山が日本列島を支える軸受けになりました。

I made the needle of a compass in the shape of Japan. It enables you to
intuitively know the direction you are standing in Japan without relying on
north-south-east-west information. When I held the compass in my hand,
I got a more real sense of the direction in Japan I was facing than
I ever had before. The center of the needle is right in the position of Mt. Fuji,
so it became the bearing that supports Japan.

Compass of Japanese Islands 292 | 293

それは数式のように生長している
原 研哉(グラフィックデザイナー)

Art that Grows with the Beauty of a Mathematical Formula
KENYA HARA Graphic Designer

　鈴木康広のスケッチは、数学者が黒板に縷々と書きつける数式に似ている。数式というと堅苦しいが、数学とは元来ロマンティックなもので、数という抽象概念を用いて世界の普遍をうたいあげる詩のようなものでもある。天才的な数学者と同じくらいに数に関する感性があるなら、難解な定理もおそらくは流麗な音楽のように感じるのではないだろうか。天才でなくとも、ピタゴラスの定理などは図としてながめても美しい。
　鈴木康広のスケッチは、何かを見てそれを再現する素描のようなものではなく、頭の中にあるイメージの進み方をヴィジュアライズしたものである。それは鈴木康広が発見した世界の読み方のようなもので、僕はこれを見た時に、天才数学者によってすらすらと書き出されていく美しい数式のようだと思った。数理が触れているのと同じものに触れているように感じるのだ。
　初めてこのスケッチを目にしたのはもう何年も前のことだ。自身の作品集を作りたいと言って鈴木康広は僕のところに現れた。《まばたきの葉》(P.114-125)や《ファスナーの船》(P.154-169)など、独特のイマジネーションを持った彼の初期作品のスケッチをその時に見せられた。それは、作品が着想された時のイメージの原理を説明するために描かれたもののようだったが、何かをかたどるというより、彼が発見しつつある世界の手がかりのようなものにも見えた。さらに言えば、それはひとつの作品のイメージを越えて、もうひとつ上のイメージの階層へと生長していくもののように見えたのである。
　誤解を恐れずに言うなら、このスケッチこそ彼のアートの核心で、実際の作品はそのアプリケーションに過ぎないのではないか。そう思われるほどに、それらのスケッチは旺盛なイメージの喚起力を持っていた。だから僕は、単なる作品の解説や補足ではなく、むしろこれを主菜として作品集を編んでみたらどうかと勧めたのである。
　結果として、鈴木康広はその後に膨大なスケッチを描いた。案の定その展開は素晴らしく、スケッチが彼自身の創作の水先案内をはじめたように見えた。ひとつの作品はスケッチで反芻されることによってさらなるイメージとして生長する。おそらくは、彼自身も自分の生み出すスケッチに触発されて、さらなるイメージの位相、あるいは新たな作品の可能性を発見し続けているのではないだろうか。
　たとえば《ファスナーの船》は、最初はリモコン操作によって池の水面をかき分けて進む模型の船であった。これを海を開きながら進む船

のスケッチとしてその規模を拡大させることによって、瀬戸内国際芸術祭2010において人の乗れる船が実現した。ファスナーの船は本当に瀬戸内の凪いだ海面を開いていったのである。スケッチはさらに太平洋を進む巨大タンカーとなり、地球を開いていくファスナーとして描かれていくわけで、これが実現するにせよ、そうでないにせよ、ファスナーの船の着想が僕らにもたらしてくれる詩的なイマジネーションはスケッチによって極大化されたことになる。数式のように美しいと感じるのは、端緒のイメージがこのように壮大なイメージとして飛翔していくのを見るときである。

　本書には、長い時間を経てようやく完成した鈴木康広のスケッチが満載されている。彼が見つめようとしている世界の無辺の広がりが、ここから確実に見えるはずである。

　　　Yasuhiro Suzuki's sketches resemble the mathematical formulas a mathematician scribbles all over the blackboard. The mention of "mathematical formulas" gives a scholastic and tedious impression. But mathematics is romantic by nature; it's a kind of poetry that expresses universal truths of our world through the abstract concept of numbers. Someone as sensitive to numbers as a mathematical genius would likely regard a difficult theorem in the same way as a beautiful, flowing melody. And you don't have to be a genius to appreciate the beauty of diagrams of formulas like the Pythagorean Theorem.

　　　Suzuki's sketches aren't a reproduction of something seen but a visualization of the progress of images in his mind. They're like a guide to reading the world of his discoveries. My initial impression of the sketches was that they looked like elegant formulas written out effortlessly by a mathematical genius. It seemed to me that they were concerned with the same sort of things as mathematical principles.

　　　I first saw the sketches several years ago when Suzuki approached me about putting a collection of his artwork in book form. I was enchanted by the sketches of "Blinking Leaves (P.114-125)," "Ship of the Zipper" (P.154-169), and other early works that embody Suzuki's unique imagination. Apparently they were drawn to explain

the principles behind his original conceptions for the works. But I thought the sketches looked more like clues to a world he was beginning to discover than models of existing objects. By way of elaboration, the sketches appeared to be not simply images of a particular artwork but images that held the promise of maturing into a higher stratum.

If I may risk being misunderstood, I would say that it is sketches which are the essence of Suzuki's art; the actual artworks are merely applications. The sketches have such a great power to evoke images that I couldn't help but think so. So I suggested that he put together an artwork collection with the sketches as the main dish rather than as mere commentary or material supplementary to the artwork.

That suggestion resulted in Suzuki drawing a voluminous amount of sketches. As I suspected, further development of the sketches gave wonderful results. It felt to me like they were beginning to steer Suzuki's creations. Sketches were a means of pondering over a work; from initial images, additional images emerged and the work matured. It's my guess that the sketches Suzuki creates inspire him to the next phase of images. Perhaps this is the reason he continues to discover possibilities for new works.

"Ship of the Zipper", for example, was originally a model boat operated by remote control to glide over the surface of a pond. Suzuki expanded the scale of the model boat by sketching a large boat that zips open the ocean. This vision was turned into a real boat that people could ride in and was shown at the Setouchi International Art Festival 2010. The zipper ship really did zip open the calm waters of Setouchi. Other sketches depict a giant zipper tanker that sails on the Pacific Ocean and opens up the earth. This may or may not become a reality. Nevertheless, the sketches maximize the poetic imaginings Suzuki gives us with his idea of a zipper ship. I'm reminded by Suzuki's sketches of the beauty of mathematical formulas whenever the original images soar to transform into spectacular images such as this.

The sketches in this collection, long in the making and finally completed, are a good startingn point from which to view the vast and boundless world envisioned by Yasuhiro Suzuki.

生命の光源
茂木健一郎（脳科学者）

The Light Source of Life
KENICHIRO MOGI Brain Scientist

　人はいつも、何かを待ち構えているのだろう。日常という慣性の中で、昨日とまるで同じ今日という退屈をやり過ごしながら、瞬きをした次の刻、世界が全く違った場所になっているのではないかとどこかで胸をときめかせている。

　鈴木康広さんの作品との出会いは不意打ちだった。知り合いに連れられて、研究室にふらっとやってきたご本人からの、スライドと模型を使ったプレゼンテーションに接したのである。耳を傾けるうちにどんどん惹き付けられていって、自分の周囲の空気の温度が高くなるのを感じた。もうとっくに忘れていたと思っていた、幼き日のざわめきを思いだした。気付くと私は、回想の中で幼稚園の砂場の横に立っていて、いつの間にか日暮れていたその空を見上げていたのである。

　《遊具の透視法》(P.38-49)は鈴木さんが世界に出るきっかけとなった作品。そこには作家の全てが凝縮されている。夜の公園。遊具に投影される、昼間の子どもたちの遊ぶ姿。ぐるぐると回るそのグローブジャングルの骨格に映像が映り、その残滓が心にしみる。そこだけぽっかりと明るくて、どこか、永遠の夕映えのようでいて。

　不思議なことに、遊ぶ子どもたちは、目の前の生身の子どもたちとは違った属性をすでに与えられている。イデアの世界に映ったかつての自分たちの姿を見て、私たちは、立っている足裏の砂の感触を確認するのだ。

　アートの力。この世の現実よりもさらにリアルな何かを私たちの前に提示してくれること。《遊具の透視法》を見て、私たちは初めて子どもとは何か、遊びの時間とは何かを理解する。新しい視点を獲得する。それは、惑星の発見や、未知の大陸への漂着に等しい「事件」なのだ。

　鈴木さんの作品には、木漏れ日のようなやわらかな気配がある。《まばたきの葉》(P.114-125)は、それを設置した場所の現実を変える。子どもたちは我を忘れて「まばたきの葉」を拾って白い幹に差し込むことに熱中する。ひらひらと降りてくる「まばたき」の紙片が、生まれて初めて見た雪のように、会場を満たす。人間精神にとっての最大の危機は、「初めて」の感触を忘れてしまうことだろう。脳の神経細胞は、一度目の提示に対して最大の反応を示し、二度目、三度目と次第に逓減していく。それは、避けられない生理現象であると同時に、私たちの生命の文法である。だからこそ、曇った目をアートの力によって定期的に晴らしてあげなければならないのだ。

《まばたきの葉》を見上げる子どもたちの表情の輝きの中に、私たちが命の「階段」を上る際のコツがある。レヴィ=ストロースが言うところの「ブリコラージュ」。ありとあらゆるものを総動員した器用仕事としてのアートの作用が、そこに目撃される。

思えば、感性を再生するために、私たちは何でもするのだ。そよ風の中を歩きもするし、目を閉じてぐるぐると回ってみることもする。雪の斜面を転がることだって。アートの持つ作用は、直接的であり、浸透的であり、ある程度再現可能である。鈴木さんが子どもの頃熱中したという「ぱらぱら漫画」もまた、生きることに「目眩」を取り戻すためのブリコラージュである。

心臓が脈動し、肺が呼吸するように、私たちは揺れ動くことでしか、自分たちの命を確認できない。願わくば、その戸惑いの中にやさしい木漏れ日が交錯しさえすれば。

瀬戸内国際芸術祭2010にも出品された《ファスナーの船》(P.154-169)のように、私たちは時にこの現実の皮膜を切り開いてみたくなる。その向こうに、私たちの生命を照らし続けている「光源」を確認するために。

生命の光源に至る道を示すこと。それがアートの使命である。《遊具の透視法》で浮かび上がる子どもたちの向こうから差し込んでくるもの。《まばたきの葉》が置かれた場を上から照らすもの。生命の光源を新たにするものが、私たち自身の魂の揺らぎであることを、鈴木さんはきっと知っている。

その時、私たちの中の子どもが、ふたたび走りだすのだ。夢中になって光を目指して。

People always seem to be lying in wait for something. Within the inertia of daily life, as we endure the boredom of todays that are just like yesterdays, somewhere inside we excitedly imagine that the world might be a completely different place in the next moment after we blink.

I had a surprise encounter with the artwork of Yasuhiro Suzuki at a research lab an acquaintance of mine took me to. Suzuki strolled in and began a presentation using slides and models. As I listened, I became increasingly fascinated; I felt the temperature of the air around me heat up. I began to remember the murmur of voices from

childhood days that I thought I had long forgotten. Suddenly I recalled standing beside the sandbox at the kindergarten; the sun had set before I realized it and I was looking up at the sky.

"Perspective of the Globe Jungle" (P.38-49), which brought Suzuki public recognition as an artist, epitomizes his art. A park at night. The figures of children playing in the daytime projected on playground equipment. Their images are reflected on the framework of the Globe Jungle as it whirls around and these remnants touch the heart. A single bright hole in the darkness that feels somehow like an eternally setting sun.

Strangely, the playing children have already been differentiated from the flesh-and-blood children right in front of us. As we watch our past selves reflected on the abstract world of ideas, we confirm the feel of the sand under our feet.

The power of art presents us with what is more real than the realities of the world. We look at "Perspective of the Globe Jungle" and for the first time we realize what children and playtime are all about. We have acquired a new perspective. It is an "event" comparable to discovering a new planet or being cast ashore on an uncharted continent.

Suzuki's works possess a hint of softness like the light that filters through trees. "Blinking Leaves" (P.114-125) is an installation that transforms the reality of venues where it is set up. Children lose themselves to become completely absorbed in chasing after the blinking leaves and sticking them into the white tree trunk. As you watch the blinking pieces of paper flutter down and fill up the exhibition space you are reminded of your first glimpse of snowflakes.

For the human mind, forgetting the feel of "the first time" is the greatest crisis. The neurons in the brain show the strongest reaction to first presentations, and the reaction gradually diminishes the second and third time. It is an unavoidable physiological phenomenon and also the grammar of human life. And so we need art on a regular basis to clear away the clouds in our eyes.

In the shining faces of children looking up at "Blinking Leaves"

we see the secret to climbing the "ladder" of life. Levi-Strauss calls it bricolage. We witness it in art, which makes creative and resourceful use of everything at hand.

An example is our inclination to do anything to reproduce emotions. We talk a walk in a gentle breeze; we close our eyes and spin around. We may even tumble down a snowy slope. The effects of art are direct and sink in; they are reproducible to some extent. The flip book, which Suzuki says he was engrossed in as a child, is also a form of bricolage that brings back lightheartedness and wonder to life.

Just as the heart beats and the lungs breath in and out, it is only by wavering back and forth that we confirm our lives. Hopefully, gentle light will filter through the trees to guide us when we lose our way.

"Ship of the Zipper" (P.154-169) shown at the Setouchi International Art Festival 2010 zipped open the ocean. In the same way, we occasionally get the urge to tear open the veil of reality. We get this urge in order to affirm the "source of light" on the other side that steadily illuminates our lives.

Pointing the way to the road leading to the light source of life —this is the mission of art. It is what shines through from the other side on the images of the children in "Perspective of the Globe Jungle." It is what illuminates the "Blinking Leaves" venues from above. Yasuhiro Suzuki knows that it is our souls themselves in their wavering that renew the light source of life.

It is then that the child in us begins to run again, enthralled, toward the light.

シンプルな疑問
川内倫子（写真家）

A Simple Question
RINKO KAWAUCHI Photographer

　鈴木くんの作品に対峙するといつも幼い頃を思い出すのはなぜだろうか。きっと初めての体験を思い出すからだろう。

　初めて海に入ってびっくりするぐらい海の水がしょっぱいと気づいたときのこと、初めてかぶとむしの幼虫を見て気持ち悪いと思ったこと、初めて船に乗って船酔いしたこと、初めて夜店のりんご飴の赤にうっとりと魅せられたこと、初めて死ぬってなんだろうと考えて夜眠れなくなったこと。

　たくさんの初めての発見。年齢を重ねるとそういった体験というのはだんだん少なくなってくる。そのぶん怖いことも減ったし要領もよくなった。生きやすくなった。

　でもそれは同時に感受性を麻痺させる。緊張感を奪う。なんとなく過ぎて行く毎日に疑問を持ちつつ流される。でも鈴木くんはあの頃の感覚のまま作品をつくり続けている。どうしてわたしたちは生きてるんだろう、というシンプルな疑問。ある意味それは恐怖でもある。そこから目を背けないで、鈴木くんは彼なりのやり方でこの世界の探求を続けていく。それはどの年代の人にも届く方法だ。だって、わたしたちははじめからそれを知っていたのだから。

　たとえば、回転するグローブジャングルに映し出される映像《遊具の透視法》(P.38-49)を見て胸をしめつけられるような気持ちになった人はたくさんいるだろう。もう戻れないいつかのあの感覚がそこに閉じ込められている。手が届きそうでもう届かないあの日のこと。

　それは《現在／過去》(P.66-69)のスタンプによってもシンプルに、残酷に、遊び心と一緒に表現されている。それはセンチメンタルな感情ではなくただの事実として。それを見つめるのはあの頃の目。

　そういったことを鈴木くんの作品を通してあらためて気づくのだ。あの全身が目であり耳であり感受性の塊だった頃に感じた、わたしたちの世界との向かい合い方を。

　Why is it that confronting the artwork of Yasuhiro Suzuki always brings back memories of my childhood? It must be because it causes me to remember first experiences.

　The first time I waded into the ocean and discovered how surprisingly salty sea water is; the first time I saw the larva of a unicorn beetle and thought it looked pretty grotesque; the first time

I rode in a boat and got seasick; the first time I saw a candy apple at one of the night stalls at a festival and was enchanted with the color; the first time I wondered what it would be like to die and couldn't get to sleep at night.

Lots of first time discoveries. As we grow older, we have fewer and fewer such experiences. What frightened us also diminishes in the same proportion though, and we become better at handling things. It becomes easier to live.

At the same time our sensitivity is anesthetized. Our feelings of tension are stolen away. We get carried along as we are questioning the colorlessness of our passing days. But Suzuki brings adolescent sensitivity to his art. What are we living for? It's a simple question. In a way, it's also a frightening one. Without looking away from the question, Suzuki continues in his own way to explore the world. The method he uses reaches all of us, whatever age we are. That's natural — we all knew it from the beginning.

An example is "Perspective of the Globe Jungle" (P.38-49). Surely there are many people whose hearts ache on seeing the images projected on the whirling Globe Jungle. Enclosed there are feelings from a past they can never go back to. A day that seems within reach, but is forever out of reach.

This is also expressed simply, playfully, and yet cruelly with a stamp in the work "Present/Past" (P.66-69). It is presented as a fact of life that dispenses with sentimentality. The work looks at those days of our childhood.

We become aware of these things once again when we see Suzuki's artwork. Yasuhiro Suzuki faces our world in the way we used to do when our whole body was eyes, ears, and a bundle of sensitivity.

鈴木康広と《募金箱「泉」》をめぐって…
青野和子(原美術館主任学芸員)

Thoughts on Yasuhiro Suzuki and "Donation Box Called Well"
KAZUKO AONO Curator, Hara Museum of Contemporary Art

りんご、キャベツ、チョコレート、スプーン、マッチ、綿棒、落書き帳、けん玉、万華鏡、色鉛筆、時計、眼鏡、パズル、椅子、ファスナー…楽しげなモノの名前の数々が、この本の〈掲載作品リスト〉のタイトル欄に踊っている。はたしてこれは美術作品集なのだろうか?

鈴木康広は幼少期、家族が営むスーパーマーケットのレジスターのそばで、いつも工作ごっこをしていたそうだ。うず高く積み上げられている食品や日用品に囲まれて遊び放題だった鈴木少年は、対価や機能を無視したそれらのモノたちとの関わり方(使用法)について、目を輝かせながら独自の探求と試行錯誤を重ねていったに違いない。鈴木は、そんな頃の幸福な体験を自身に繋ぎとめておくために、今日も、どこか懐かしさや温かみの感じられる作品を、一見ローテクな手法で作り続けているのかもしれない。たとえば、《目薬の銃》(P.202-205)は、「目薬をさす」という子供の頃に恐怖に襲われた体験を、銃を模した小さな透明容器のなかに目薬を入れることでかたちにした作品であり、《バケツの切り株》(P.254-257)は、生木の幹が多くの水を湛えていることに想を得た、水面に落ちる水滴を木の年輪に見立てた作品なのだから。

かつてデザインとアートの間には〈用途と機能の有無〉という深い溝があった。その存在さえ知らぬ間に、軽々と飛び跳ねながら両者の間を往還していた鈴木少年は、そのまま成長し、やがて、作家・鈴木康広となった。

さて、かつてレディメイドに光を当て、機能を剥奪した既製品にタイトルと署名を施して展覧会に出品し、〈現代美術の父〉と呼ばれたのはマルセル・デュシャンだったが、その代表作と同じタイトルを持った作品が、本年(2011年)初夏から原美術館において公開されている。鈴木康広作《募金箱「泉」》(P.278-281)である。(註1)

「原美術館は私立美術館だよね。その活動支援のために、鈴木康広クンに募金箱を作ってもらって寄贈したいのだけれど…。」原美術館の賛助会員であるN氏から前代未聞の提案を受けたのは昨夏の終わり。N氏と私がたまたま、内外の大型美術館のロビーやコンビニエンスストアのカウンターなどに設置されている〈募金箱〉について四方山話をした数日後のことだった。(大震災の半年以上も前のこと。N氏は、昨年、鈴木康広が瀬戸内芸術祭で発表した作品《ファスナーの船》(P.154-169)の

制作協力をした造船会社のオーナーでもある方だ。)
　しばらくして作家自身から出たプランは、美術館の壁に穿たれた裂け目にコインを投入すると「ポチャン」と水音が響き、その奥に(金種によって異なる)無限の映像空間が広がる──という、こちらの〈募金箱〉の予想をはるかに超えたインタラクティヴでアトラクティヴなものだったのだ。

　「事物は、ぼくらとまったく同じく、物質としての生を持っている。」鈴木康広が生まれた年に刊行された本のなかでそう語ったのはジャスパー・ジョーンズだった。(註2)
「コインはそれを投入する人の分身です。」この作品において鈴木は、人が一枚のコインをスリットに投入する動作そのものに象徴性を持たせた。募金という行為が、金額の多寡に関わらず、相手に対して思いを伝え、その明日を動かす力を持つことを、実在する泉にコインを投げ入れた時の波紋に見立てて顕在化させたのだ。

　その後発生した未曾有の大災害・東日本大震災を受けて、年内に寄せられた募金はすべて被災地の美術活動復興支援のための義援金に充てられることになったが、ストレートで明快な鈴木のコンセプトは、支援の対象者を変えてそのまま引き継がれた。(註3)

　この《募金箱「泉」》や《ファスナーの船》は、近年、美術に限らずあらゆるジャンルにおいて盛んに見受けられるようになってきた、領域横断的なクリエーションと位置づけられるだろう。現代美術の先人たちの軌跡を踏まえつつ、分野の異なる多くの専門家の手を借りて鈴木康広が制作した〈用途も機能もある美術作品〉というわけだ。
　自宅のスーパーの片隅でひとり工作に興じていた少年は、ユニークな発想力と柔軟な感性に磨きをかけながら大人になり、あらゆるメディアや他者を取り込む術を知った。身近なモノを通して壮大な宇宙をも見据え始めた鈴木康広の今後の活動から、ますます目が離せそうにない。

　　　註1　英題は、"Donation Box Called Well" とした。「泉」の英語はfoutainとなり、意味が異なってくるので、wellとした。その外観は、デュシャンの《遺作》(通称)を彷彿とさせる。

註2 東野芳明「ジャスパー・ジョーンズ そして／あるいは」美術出版社、1979年、P.191

註3 このたびの東日本大震災において亡くなられた方々のご冥福を、心よりお祈り申し上げます。一枚のコインに込められた募金者の思いや祈りが、ささやかなアート支援を通して、被災地に暮す方々に届くことを願ってやみません。

Apples, cabbages, chocolate, spoons, matches, cotton swabs, scribbling notebooks, kendama toys, kaleidoscopes, colored pencils, clocks, glasses, puzzles, chairs, zippers…the names of all sorts of delightful objects dance in the title column of the list of artworks in this book. Is this really an art collection?

I heard that as a young child, Yasuhiro Suzuki used to sit beside the cash register in the supermarket his family ran and play at making things. Young Suzuki, surrounded by tall stacks of food products and household items, must have played to his heart's content, eyes aglow, engrossed in his own special way in exploring various ways to handle (use) all of those things without regard for their value or function; trying, failing, and trying again. To retain the happy feelings of thosechildhood experiences, Suzuki is probably at work today, too, employing methods which at first glance seem to be analog but are often highly technical continuing to create works of art that somehow have a nostalgic feel and warm the heart. Good examples are "Eye Dropper" (P.202-205), a work that gives physical substance
to the frightening childhood experience of putting eye drops in the eyes by fashioning a small transparent container resembling a gun and putting eye drops in it, and "Bucket Stump" (P.254-257), a work inspired by the large amount of water contained in the trunks of living trees that likens the concentric circles of ripples made by a water drop falling on the surface of the water in a bucket-shaped tree trunk to the annual growth rings of a tree.

In the past, art and design were separated by the deep chasm of "whether or not a work had utility and function." Young Suzuki moved back and forth between art and design vaulting effortlessly over a chasm he didn't even know was there, and before long, matured in this way into the artist, Yasuhiro Suzuki.

Marcel Duchamp, called "the father of contemporary art," shone the spotlight on "readymade" by taking manufactured objects out of the context of their function, giving them a title and his signature, and showing them at art exhibitions. A work whose Japanese title reminds us of Duchamp's representative readymades work has been on exhibit at the Hara Museum of Contemporary Art since early this summer (2011)—Yasuhiro Suzuki's "Donation Box Called Well[1]" (P.278-281).

"The Hara Museum is a private art museum isn't it? I'd like to make an endowment, and why don't we have Yasuhiro Suzuki make a donation box to give other people an opportunity to support the museum's activities?" This unprecedented suggestion was made to me at the end of last summer by Mr. N, who is one of the museum's supporting members. It was a few days after Mr. N and I happened to be talking about donation boxes placed in the lobbies of large museums in Japan and other countries, on the counters of convenience stores, and all sorts of other places. (This was more than half a year before the Great East Japan Earthquake occurred. Mr. N is also the owner of a shipbuilding company and collaborated in constructing the boat which Suzuki exhibited as "Ship of the Zipper" (P.154-169) last year at the Setouchi International Art Festival.)

After a while, the artist submitted a plan for opening up a slit in the museum wall; whenever coins were dropped through, the sound of "plopping" into water would be heard and the donator would be able to see an unbounded space of images beyond the slit (the images seen would depend on the sort of a coin dropped)... an interactive and attractive "donation box" that far exceeded the one we were anticipating.

"Things are the same as us; they have a life as material substances[2]." This comment by Jasper Jones was recorded in a book[3] published the year Yasuhiro Suzuki was born.

"The coin is the alter ego of the person who puts it in the donation box." Suzuki created the work on the concept of making the action of a person putting a coin through the slit symbolic in itself. The act of donation, regardless of the amount of money, conveys one's feeling to the receiver and has the power to put the receiver's tomorrow in motion; Suzuki makes this evident by likening it to the pattern of ripples that are created in a real fountain by throwing in a coin.

Later, the Great East Japan Earthquake occurred. In the wake of this unprecedented disaster, the Hara Museum decided to donate all contributions received within the year toward assisting the recovery of art activities in the disaster areas. Although the object of assistance[4] was changed, Suzuki's straightforward concept lived on.

"Donation Box Called Well" and "Ship of the Zipper" will no doubt be defined as cross-disciplinary creations, which in recent years have become common not only in art but in all sorts of genres. Suzuki's artwork — produced in the tracks of forerunners in contemporary art and with the support of many experts in other fields — is art with utility and function.

The young boy sitting by himself in a corner of the family supermarket enjoying making things refined his unique creative power and flexible sensitivity as he grew up to become an artist who knows how to creatively employ all kinds of mediums and the expertise of other people in the creation of his art. Working with objects familiar to all of us, he is beginning to envision even magnificent universes With the promise of much fascinating artistic activity by Yasuhiro Suzuki in the future, we can't help but keep our eyes glued on him more than ever before.

Note 1 Duchamp's representative work "Fountain" is translated into Japanese as Izumi. This word is also used in the Japanese title of Suzuki's work "Bokinbako Izumi," although it has been translated as "well" in English to avoid confusion with a "fountain" of gushing water. The exterior of Suzuki's work is reminiscent of Duchamp's posthumous work titled "Etant donnés" (alias).

Note 2 An English translation of the quote given in Japanese in the book.

Note 3 Tono, Yoshiaki. Jasper Johns and/or. (Tokyo: Bijutsu Shuppan-sha, 1979), p.191.

Note 4 We pray for the repose of the souls of all those who lost their lives in the Great East Japan Earthquake. It is our sincere wish that the donators' feelings and prayers contained in each coin will reach the people living in the afflicted areas, and that these donations willhelp in some small way to support art activities there.

作品リスト

上／下
1997
サイズ：判子 6×1.7×1.7cm
　　　　紙 1.5×12.3×16.5cm
素材：木材、ゴム印、紙

景色の万華鏡
2001
サイズ：23×23×23cm
素材：プラスチック、レンズ、鏡、
　　　ビデオカメラ、スピーカー

綿棒の照明
2000
サイズ：9.1×10.9×8.1cm
素材：綿棒、電球

落書き帳
2002
サイズ：1×25.5×35.5cm
素材：画用紙

椅子の反映
2001
サイズ：椅子 3.5×2×2.5cm
　　　　装置 10×80×80cm
素材：木材、アクリル樹脂、モーター、
　　　ビデオカメラ、赤外線センサー、
　　　プロジェクター

現在／過去
2002
サイズ：0.6×2.5×6cm
素材：木材、ゴム印

境界線を引く鉛筆
2002
サイズ：0.8×17×0.8cm
素材：色鉛筆、接着剤

ペットボトルの鉛筆削り
2001
サイズ：3×3×3.1cm
素材：プラスチック、刃、ペットボトル

時計の針は透明な円盤を空中に描く
2003
サイズ：50×100×100cm
素材：ステンレス・スチール、モーター、コントロール
　　　シーケンサー、プロジェクター、DVDプレーヤー
協力：安達 亨・板倉俊介（AC部）、
　　　STUDIO DREAM夢空間研究所、
　　　hashimoto yukio design studio Inc.

まばたき眼鏡
2001
サイズ：5×14×17cm
素材：プラスチック、モーター、
　　　ソーラーパネル

遊具の透視法
2001
サイズ：320×230×230cm
素材：グローブジャングル、プロジェクター、
　　　スピーカー、DVDプレーヤー
協力：森田菜絵、西山 孝、前田聖志、小川謙治、
　　　豊浜弥生、掛本純子、今出菜穂子、
　　　峯崎美奈子、野村志乃婦、長江 努、
　　　NHKデジタル・スタジアム
　　　日都産業株式会社

りんごのけん玉
2003
サイズ：19×7×7cm
素材：木材、ひも

まばたきの時計
2003
サイズ：9×19×9cm
素材：木材、写真、モーター、アクリル樹脂

りんごが鏡の中に落ちない理由
2003
サイズ：10×20×20cm
素材：りんご、鏡

心拍時計
2003
サイズ：150×75×75cm
素材：スチール、モーター、コンピューター、
　　　心拍センサー、スピーカー、
　　　プロジェクター
協力：岩井俊雄、檜山敦、日本科学未来館、
　　　山口大学時間学研究所

まばたきの葉
2003
サイズ：葉　10.5×5.5×0.02cm
　　　　装置　600×80×80cm
素材：紙、繊維強化プラスチック、
　　　送風機、木材、ベンチ
協力：桑原治男、島田まゆみ、武田信之、
　　　NHKデジタル・スタジアム、
　　　株式会社ワコールアートセンター

時間を測るスプーン
2004
サイズ：2×12×4cm
素材：ガラス
協力：滑川敏夫（東京大学生産技術
　　　研究所ガラス工房）

キャベツの器
2004
サイズ：15×20×20cm
素材：紙粘土
協力：株式会社日本デザインセンター
　　　原デザイン研究所

木の葉の座布団
2004
サイズ：5×3×0.03cm
素材：紙
協力：株式会社竹尾、
　　　株式会社日本デザインセンター
　　　原デザイン研究所

ファスナーの船
2004
サイズ：ラジコン　25×60×20cm
　　　　船　300×1137×465cm
素材：ラジコン／繊維強化プラスチック、
　　　モーター、ラジオコントロールユニット
　　　船／漁船、発砲スチロール、
　　　ウレタン塗装、繊維強化プラスチック
協力：瀬戸内国際芸術祭実行委員会、
　　　株式会社アートフロントギャラリー、
　　　有限会社根本造船所、
　　　瀬戸内マリン、日本小型船舶検査機構、
　　　株式会社サンクアール、株式会社
　　　晃洋技研、株式会社モールド工業

水の素質
2004
サイズ：オブジェ　70×45×45cm
　　　　鏡　180×180×0.5cm
素材：スチール、鏡、モーター、
　　　プロジェクター、DVDプレーヤー
協力：神原秀夫、山中隆寛、TOTO株式会社

うしろ姿の模型
2004
サイズ：44×12×12cm
素材：写真、木材、モーター

りん玉の蝋燭
2004
サイズ：19×7×7cm
素材：蝋、ひも
協力：カメヤマ株式会社、面出薫、深澤直人

スプーンの蝋燭
2004
サイズ：12×4×2cm（L）
　　　　11×3×1.5cm（M）
　　　　10×2×1cm（S）
素材：蝋
協力：カメヤマ株式会社、面出薫、深澤直人

？のあめ
2005
サイズ：2.3×10×18.5cm
素材：プラスチック、あめ玉

炎のマッチ
2005
サイズ：0.5×4×5cm
素材：紙、マッチ

目薬の銃
2005
サイズ：1.4×8.3×5.3cm
素材：プラスチック、目薬

気配のクッキー
2005
サイズ：0.5×6×6cm
素材：小麦粉、バター、卵、砂糖、アルミニウム

自画像のパズル
2005
サイズ：1×15.5×33cm
素材：アクリルミラー、木材

水平線の消息──色鉛筆
2005
サイズ：0.8×17×0.8cm
素材：色鉛筆、接着剤

水平線の消息──ひも
2005
サイズ：215×340×120cm
素材：ビニールケーブル、ステンレス・
　　　スチール、モーター、スライダー、
　　　プロジェクター、DVDプレーヤー
協力：小西義幸・米良忠久（東京大学生産
　　　技術研究所試作工場）、
　　　株式会社ワコールアートセンター、
　　　三菱地所アルティアム

りんごの天体観測
2006
サイズ：38×49×49cm
素材：プラスチック、鏡、LED、モーター、
　　　電球、木材、スチール

スープの満ち欠け
2006
サイズ：4×23×23cm
素材：陶器、コーンスープ

蛇口の起源
2006
サイズ：不定形
素材：蛇口、水
協力：美馬英二

空気の人
2007
サイズ：190×60×90cm
素材：プラスチックフィルム（HEPTAX）、
　　　ヘリウムガス、空気
協力：堀田真澄、吉村峰人、城土健作、
　　　溝上友里、飯田智広、
　　　天池合繊株式会社、
　　　株式会社日本デザインセンター
　　　原デザイン研究所、
　　　株式会社エアロテック

大きな空気の人
2009
サイズ: 1200×350×550cm
素材: 塩化ビニールシート、シロッコファン
協力: 「空気の港」ボランティアスタッフ、
　　　飯田智広、大曾根興光(株式会社
　　　エアロテック)、DPA

バケツの切り株
2007
サイズ: 35×40×27cm
素材: 繊維強化プラスチック、アルミニウム
協力: 服部一成

銀閣寺のチョコレート
2007
サイズ: 6.8×7.2×6.3cm
素材: プラスチック、アルミホイル
協力: 21_21 DESIGN SIGHT、
　　　Naoto Fukasawa Design

繊維の人
2009
サイズ: 185×55×30cm
素材: ブレスエアー、アクリル樹脂、
　　　エアシリンダ、電磁弁、コンピューター
協力: 小西義幸・米良忠久(東京大学生産
　　　技術研究所試作工場)、
　　　小笠原圭吾、東洋紡株式会社、
　　　株式会社日本デザインセンター
　　　原デザイン研究所

自針と分針
2009
サイズ: 125×90×50cm
素材: スチール、アクリル樹脂、
　　　液晶ディスプレイ、コンピューター、
　　　カメラ
協力: 松村成朗・富樫政徳・大谷智子・
　　　山崎俊彦・相澤清晴(東京大学相澤
　　　研究室)、DPA

木のこま
2010
サイズ: 4×2.5×2.5cm
素材: 木材
協力: 小西義幸・米良忠久(東京大学生産
　　　技術研究所試作工場)、
　　　株式会社more trees design

空気の鞄
2010
サイズ: 32×25×10cm
素材: 塩化ビニールシート
協力: 東京大学先端科学技術研究センター
　　　中邑研究室

募金箱「泉」
2011
サイズ: スリット 6×0.4cm
素材: ミクストメディア
協力: 武松幸治(E.P.A)、株式会社ゴトー
　　　工芸、有限会社ソルカーザ
原美術館蔵

まばたき採集箱
2011
サイズ: 12×17×8cm
素材: 木材、デジタルカメラ、金網、バンド

まばたき証明写真
2011
サイズ: 208×120×80cm
素材: 木材、蛍光灯、鏡、コンピューター、カメラ
協力: 狩野佑真、鈴木雄介、竹内晃一、
　　　望月美緒、飯田萌奈

日本列の方位磁針
2011
サイズ: 1.6×6×6cm
素材: アルミニウム、ステンレス、ガラス
協力: 小西義幸・米良忠久(東京大学生産
　　　技術研究所試作工場)

謝辞

　本書を実現するにあたり、原研哉さんをはじめ日本デザインセンター原デザイン研究所の皆様には多大なるご支援とご協力をいただきました。この場をお借りして心より御礼申し上げます。特に本書を担当してくださった美馬英二さんとのキャッチボールはとても有意義な時間でした。美馬さんの全く妥協しない姿勢に鼓舞され、思いがけない新たなスケッチが描けたことが多くありました。

　写真家の川内倫子さんに今回新たにプリントしていただいた作品写真は、僕のイメージを超えた風景を見せてくれました。川内さんの目を通して作品を見ることが、いつしか僕の創作のもうひとつの喜びとなっていました。脳科学者の茂木健一郎さん、原美術館主任学芸員の青野和子さんからいただいたご寄稿によって、読者への入口を大きく広げていただくとともに、僕自身大切なことに気付かせていただいた思いです。お忙しい最中のご寄稿に心より御礼申し上げます。

　初対面の僕からの作品紹介に、長時間じっくりと耳を傾けてくださり、長年の出版への思いを叶えてくださった青幻舎の安田英樹社長、図版とテキストがパズルのように入り組む本書を最後まで冷静にまとめてくださった森かおるさん、両氏をご紹介してくださった編集者の宮後優子さんにはこの場をお借りして御礼を申し上げます。

　そして、本書に紹介されている作品をつくり続けることができたのは、中谷日出さん、長江努さんをはじめ、NHKデジタル・スタジアムを通してお世話になった皆様、東京大学の廣瀬通孝教授をはじめとする共にプロジェクトに取り組んだ多くの方々のご支援と寛大なるご協力があってのことです。特にメディアアーティストの岩井俊雄さんから、アーティストとして生きていく上で身近に学んだことの大きさは計りしれません。この場をお借りして深く感謝の意を表します。

　最後に、いつもどんなときにも駆けつけてくれる友人と、僕の作品をたのしみにしてくれているすべての人に、心より感謝の意を表します。

鈴木康広

本書の実現、並びにこれまでの作品制作において、
以下の方々、機関から多大なご協力を賜りました。
厚く御礼申し上げます。

相澤清晴	関 直子
網野奈央	竹井正和
飯田智広	武田信之
板倉善宏	谷川智洋
市川勝弘	中邑賢龍
伊藤隆志	中山修男
植田 工	滑川敏夫
内田まほろ	西村邦裕
小笠原圭吾	根本 進
岡本美津子	日野水聡子
小川謙治	檜山 敦
緒川たまき	廣瀬通孝
狩野佑真	深澤直人
門脇さや子	藤澤伸太郎
上條桂子	細川いづみ
川上秀人	前田聖志
神原秀夫	増田幸雄
北川フラム	三宅一生
桑原治男	米良忠久
小西義幸	森田菜絵
齋藤 康	森山朋絵
佐渡島庸平	箭内道彦
島田まゆみ	
鈴木育子	Alex Adriaansens
鈴木淳平	Ann Tomoko Yamamoto
鈴木智暢	Wonil Rhee

NHKデジタル・スタジアム
DIRECTIONS
東京大学生産技術研究所試作工場
東京大学先端科学技術研究センター 中邑研究室
東京大学 廣瀬・谷川研究室
株式会社AXIS
株式会社講談社モーニング編集部
株式会社日本デザインセンター 原デザイン研究所
浜松市美術館
原美術館
（50音順、敬称略）

鈴木康広
アーティスト

プロフィール
1979年　静岡県浜松市生まれ
2001年　東京造形大学デザイン学科卒業
2002年　東京大学先端科学技術研究センター
　　　　岩井研究室特任助手
2006年　廣瀬・谷川研究室特任助教
2010年　中邑研究室特任研究員

主な個展
2005年　「水平線の消息」三菱地所アルティアム（福岡）
2008年　「Aerial Being」IERIMONTI GALLERY（ミラノ）
2011年　「募金箱〈泉〉公開記念特別展示」原美術館（東京）
　　　　「BORDER——地球、まばたき、りんご、僕」浜松市美術館（静岡）

主なグループ展
2002年　「Ars Electronica Festival」OK Center（リンツ）
2003年　「The First Steps」P.S.1コンテンポラリー・アートセンター（ニューヨーク）
　　　　「サイバー・アジア——メディア・アートの近未来形」広島市現代美術館（広島）
　　　　「DATA KNITTING」DEAF (Dutch Electronic Art Festival) 03（ロッテルダム）
　　　　「時ương旅行展——TIME! TIME! TIME!」日本科学未来館（東京）、
　　　　上海科技館（上海）
2004年　Art Life vol.2 鈴木康広／山極満博展「行方不明」スパイラルガーデン（東京）
　　　　Lille 2004「Cinemas du Futur」（リール）
　　　　TAKEO PAPER SHOW 2004「HAPTIC」スパイラルガーデン＆ホール（東京）、マイドームおおさか（大阪）
　　　　「Digital Sublime」MOCA Taipei（台北）
　　　　「CAFE in Mito 2004」水戸芸術館現代美術センター（茨城）
2005年　「愛・地球博 開会式」EXPOドーム（愛知）
　　　　「Rising Sun, Melting Moon: Contemporary Art from Japan」イスラエル美術館（エルサレム）
2006年　「予感研究所 アート＋テクノロジー＋エンタテインメント＝?! 325人の研究者たちの予感」日本科学未来館（東京）
2007年　第1回企画展 深澤直人ディレクション「Chocolate」21_21 DESIGN SIGHT（東京）
　　　　Digital Public Art Exhibition「木とデジタルテクノロジーが生み出す"新しい自然"」スパイラルガーデン（東京）
　　　　「TOKYO FIBER '07 SENSEWARE」スパイラルガーデン（東京）、パレ・ド・トーキョー（パリ）
　　　　「Thermocline of Art —— New Asian Waves」ZKM（カールスルーエ）
2008年　第3回企画展 三宅一生ディレクション「XXIc.——21世紀人」21_21 DESIGN SIGHT（東京）
　　　　セビリアビエンナーレ2008 アルハンブラ宮殿（グラナダ）
2009年　「TOKYO FIBER '09 SENSEWARE」21_21 DESIGN SIGHT（東京）、トリエンナーレ美術館（ミラノ）
　　　　Digital Public Art Exhibition in Haneda Airport
　　　　「空気の港 テクノロジー×空気で感じる新しい世界」羽田空港ターミナル（東京）
2010年　瀬戸内国際芸術祭2010（香川）
2011年　第4回モスクワビエンナーレ（モスクワ）

受賞歴
2001年　第2回シヤチハタ・ニュープロダクト・デザイン・コンペティション 一席
　　　　NHK Digital Stadium デジスタアウォード2001 インタラクティブ部門 最優秀賞、デジスタアウォード2001 最優秀賞
2002年　第3回シヤチハタ・ニュープロダクト・デザイン・コンペティション 原賞
　　　　フィリップモリス・アートアワード 大賞
　　　　Ars Electronica Festival インタラクティブ部門 入選
　　　　アジア・デジタルアートアウォード インタラクティブ部門 優秀賞
2004年　東京デザイナーズウィーク「コンテナグラウンド」展 グランドプレミオ賞
2009年　グッドデザイン賞
2010年　40 under 40 アート部門
2011年　浜松市教育文化奨励賞「浜松ゆかりの芸術家」

パブリックコレクション
原美術館（東京）

Yasuhiro Suzuki
Artist

Profile
1979 Born in Shizuoka, JAPAN
2001 Graduated from Tokyo Zokei University
2002 Working in Research Center for Advanced Science and Technology The University of Tokyo,
 Iwai Laboratory Research Associate
2006 Hirose Tanikawa Laboratory Research Associate
2010 Nakamura Laboratory Project Researcher

Selected Solo Exhibitions
2005 "Note from the Sea Horizon," at Mitsubishi-Jisho ARTIUM, Fukuoka
2008 "Aerial Being," at IERIMONTI GALLERY, Milan
2011 Special Exhibition "Donation Box Called Well," at Hara Museum of Contemporary Art, Tokyo
 "BORDER — Earth, Blinking, Apples, Me," at Hamamatsu City Art Museum, Shizuoka

Selected Group Exhibitions
2002 "Ars Electronica Festival," at OK Center, Linz
2003 "The First Steps. Emerging Artists from Japan," at PS1, Contemporary Art Center, New York
 "Cyber Asia-media art in the near future," at Hiroshima City Museum of Contemporary Art, Hiroshima
 "DEAF (Dutch Electronic Art Festival) 03: DATA KNITTING," Rotterdam
 "TIME! TIME! TIME! Exploration of TIME!" at National Museum of Emerging Science and Innovation, Tokyo,
 traveled to Shanghai Science & Technology Museum, Shanghai
2004 "Art Life vol.2 Yasuhiro Suzuki / Mitsuhiro Yamagiwa," at Spiral Garden, Tokyo
 "Lille 2004: Cinemas du Futur," Lille
 "TAKEO PAPER SHOW 2004: HAPTIC," at Spiral Garden & Hall, Tokyo traveled to MyDome Osaka, Osaka
 "Digital Sublime," at Modern of Contemporary Art in Taipei, Taipei
 "CAFE (Communicable Action for Everybody) in Mito 2004," at Art Tower Mito, Ibaraki
2005 "EXPO2005 AICHI Opening Ceremony," at EXPODome, Aichi
 "Rising Sun, Melting Moon: Contemporary Art from Japan," at The Israel Museum, Jerusalem
2006 "Yokan-ken," at National Museum of Emerging Science and Innovation, Tokyo
2007 "EXHIBITION 1: Chocolate DIRECTED BY NAOTO FUKASAWA," at 21_21 DESIGN SIGHT, Tokyo
 "Digital Public Art Exhibition: TREE DIGITAL," at Spiral Garden, Tokyo
 "TOKYO FIBER '07 SENSEWARE," at Spiral Garden, Tokyo, traveled to PALAIS DE TOKYO, Paris
 "Thermocline of Art — New Asian Waves," at ZKM, Karlsruhe
2008 "EXHIBITION 3: XXIst Century Man DIRECTED BY ISSEY MIYAKE," at 21_21 DESIGN SIGHT, Tokyo
 "Seville Biennale 2008," at Alhambra Palace, Granada
2009 "TOKYO FIBER '09 SENSEWARE," at 21_21 DESIGN SIGHT, Tokyo, traveled to Triennale Design Museum, Milan
 "Digital Public Art Exhibition: Air Harbor," at Haneda Airport, Tokyo

2010 "Setouchi International Art Festival 2010," Kagawa
2011 "The 4th Moscow Biennale of Contemporary Art, at ARTPLAY, CUM, Moscow

Prize
2001 SHACHIHATA New Product Design Competition, First Prize
 NHK Digital Stadium Digista Award 2001 Interactive Art Category First Prize, Digista Award 2001 Grand Prize
2002 SHACHIHATA New Product Design Competition, Hara Prize
 Philip Morris Art Award 2002, Grand-Prix
 Ars Electronica Festival, Interactive Art Category Honorary Mention
 Asia Digital Art Award, Interactive Art Category Prize
2004 Tokyo Designers Week CONTAINER GROUND, Grand Prize
2009 Good Design Award
2011 40 under 40, ART (DESIGN STARS OF TOMORROW)
 Education and Culture Encouraging Award, from Hamamatsu-city

Public Collection
Hara Museum of Contemporary Art, Tokyo

鈴木康広			Yasuhiro Suzuki	
まばたきとはばたき			Blinking and Flapping	

発行	2011年10月25日　初版発行	First Edition　October 25, 2011
	2012年3月10日　第2版発行	Second Edition　March 10, 2012
著者	鈴木康広	Author　Yasuhiro Suzuki
デザイン	原 研哉 + 美馬英二(日本デザインセンター)	Designer　Kenya Hara + Eiji Mima (Nippon Design Center, Inc.)
編集	森かおる(青幻舎)	Editor　Kaoru Mori (Seigensha Art Publishing)
写真	市川勝弘(P.117 提供：スパイラル／株式会社ワコールアートセンター)	Photographer　Katsuhiro Ichikawa (P.117 Courtesy of SPIRAL／Wacoal Art Center)
	小原 清／Vda／amanagroup (P.134, P.137-140, P.142, P.145-147)	Kiyoshi Obara／Vda／amanagroup (P.134, P.137-140, P.142, P.145-147)
	川内倫子(P.18, P.23上, P.26, P.38, P.43, P.67, P.70, P.94, P.114, P.119上, P.170, P.174)	Rinko Kawauchi (P.18, P.23 Upper, P.26, P.38, P.43, P.67, P.70, P.94, P.114, P.119 Upper, P.170, P.174)
	小林大輔(P.262-263)	Daisuke Kobayashi (P.262-263)
	関口尚志／Vda／amanagroup(P.246)	Takashi Sekiguchi／Vda／amanagroup (P.246)
	ホンマタカシ(P.254)	Takashi Homma (P.254)
	森本美絵(P.266)	Mie Morimoto (P.266)
	21_21 DESIGN SIGHT (P.258)	21_21 DESIGN SIGHT (P.258)
翻訳	藪下リンダ(JEX Limited)	Translator　Linda Yabushita (JEX Limited)
印刷	株式会社サンエムカラー	Printer　SunM Color Co., Ltd.
	谷口倍夫(プリンティングディレクター)	Masuo Taniguchi (Printing Director)
製本	印刷設計株式会社	Binder　Print Designing Co., Ltd.
発行者	安田英樹	Publisher　Seigensha Art Publishing, Inc.
発行所	株式会社青幻舎	Higashi-iru, Karasuma-Sanjo, Nakagyo-ku,
	京都市中京区三条通烏丸東入ル	Kyoto, 604-8136 Japan
	Tel: 075-252-6766	Tel: 075-252-6766
	Fax: 075-252-6770	Fax: 075-252-6770
	http://www.seigensha.com	http://www.seigensha.com

Printed in Japan
ISBN978-4-86152-321-2 C0070

©2011 Yasuhiro Suzuki
©2011 Seigensha Art Publishing, Inc.

本書の無断転写、転載、複製を禁じます。
All rights reserved.
No part of this publication may be reproduced
without written permission of the publisher.